BEAUTY
AND THE
BEAST

A MODERN RETELLING

JEANNE-MARIE LEPRINCE
A GRAPHIC NOVEL ILLUSTRATED BY PETE KATZ

San Diego, California

Canterbury Classics
An imprint of Printers Row Publishing Group
10350 Barnes Canyon Road, Suite 100, San Diego, CA 92121
www.canterburyclassicsbooks.com

Publisher: Peter Norton
Associate Publisher: Ana Parker
Publishing/Editorial Team: April Farr, Kelly Larsen, Kathryn Chipinka,
Aaron Guzman
Editorial Team: JoAnn Padgett, Melinda Allman

Conceived, Designed and Produced by Quid Publishing,
an imprint of The Quarto Group
The Old Brewery, 6 Blundell Street,
London N7 9BH, United Kingdom
T (0) 20 7700 6700 F (0)20 7700 8066
www.QuartoKnows.com

Library of Congress Cataloging-in-Publication Data available upon request
ISBN: 978-1-68412-099-4
Printed in China
22 21 20 19 18 1 2 3 4 5

CONTENTS

INTRODUCTION

Many people believe that "Beauty and the Beast" was written by the brothers Grimm, but the truth is they just added the story to their collection. Their version, "The Singing, Springing Lark," published in 1812, is slightly different.

The original "Beauty and the Beast" was written over seventy years earlier by Gabrielle-Suzanne Barbot de Villeneuve in 1740. It was a rather lengthy affair for a fairy tale at over one hundred pages with a large cast of characters and many subplots. Villeneuve, being influenced by the female intellectuals of her time, used the story to explore notions and attitudes regarding love and women's marital rights. At the time, women rarely had a say in who they married and were encouraged to "learn to love" their spouses, who were most often selected by their fathers.

In 1756, the tale was published again in *Le Magasin des Enfants.* The story had been rewritten and abridged by Jeanne-Marie Leprince de Beaumont. She greatly simplified the plot and did away with all but the core characters. This is the much shorter version we are more used to today.

The story has its influences in much earlier stories such as "Cupid and Psyche," written by Lucius Apuleius Madaurensis in the second century AD. And according to researchers from Durham and Lisbon universities, the story's origins can be traced as far back as 4,000 years. It is unsurprising then, considering the story's lasting influence, that it has remained popular even today. There have been many, many versions reproduced in literature, film, opera, and ballet. Arguably the most famous of these are Jean Cocteau's 1946 film and Disney's 1991 animated version and 2017 live-action version. All these adaptations add something of their own to the original. Cocteau gave it the gothic style and atmosphere that has remained in most versions since. Disney added a string of well-loved characters including Lumière, the candelabra, and Mrs. Potts, the teapot.

In Leprince's version, apart from the petty maliciousness of Beauty's siblings, there is no real evil to speak of, except perhaps loneliness, longing, and rejection. These feelings are of course no small matter, but in a visual sense are less exciting to look at than a more traditional scoundrel. So in this adaptation, like the Disney versions, we have created a more tangible villain to make a nice counterpoint to the noble characters of Beauty and Beast. We hope you find Caliban as satisfyingly evil as we do!

Another mild step away from the traditional fairy tale was our depiction of Beauty herself. Many famous heroines from the classic tales are very one-dimensional. Some are brave, some are clever, but on the whole they are beautiful and little else. They are nothing more than the prize at the end of the quest. A caged bird waiting passively for a more capable man to rescue her from her plight. In our version, Beauty has a large hand in the outcome of the story. She is of course still beautiful and compassionate, but she is also strong, courageous, and skilled in more than just flower arranging and needlework.

We hope that Villeneuve and her contemporaries would approve!

DRAMATIS PERSONAE

BEAUTY AND THE BEAST

EMERY TIBON

CHARITY TIBON

VALOR TIBON

BRAMBLE

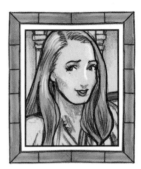

BEAST

BEAUTY

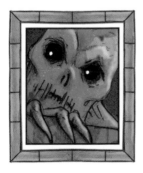

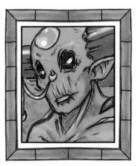

THE DEMON

CALIBAN

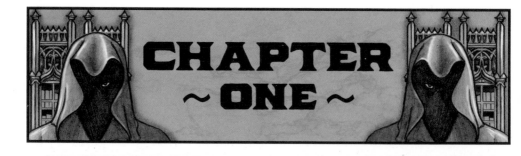

CHAPTER
~ ONE ~

A CHILLY NIGHT ON THE OAKBRIDGE ROAD, A LONG, LONG TIME AGO...

MY POOR CHILDREN! YOUR FATHER HAS FAILED YOU AGAIN. HOW DISAPPOINTED YOU WILL BE IN ME ONCE MORE.

EGAD, WHAT A STORM! I MUST FIND SHELTER SOMEWHERE, OR THE HORSE AND I WILL DROWN!

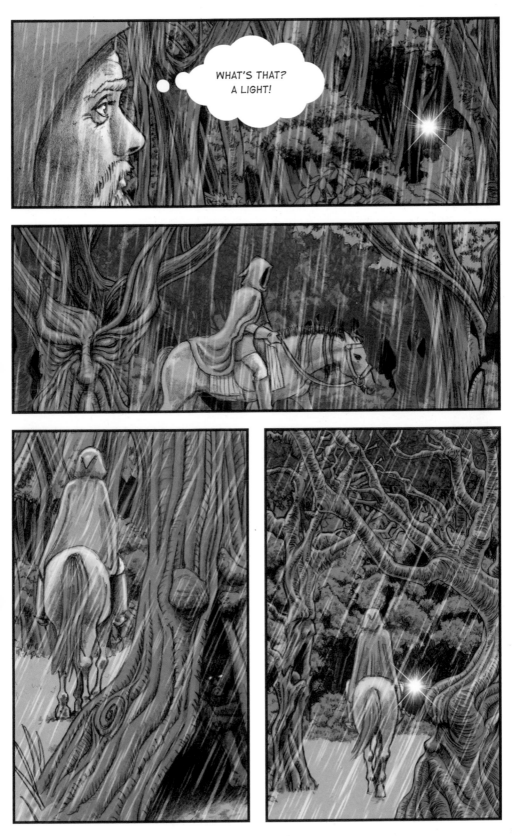

9

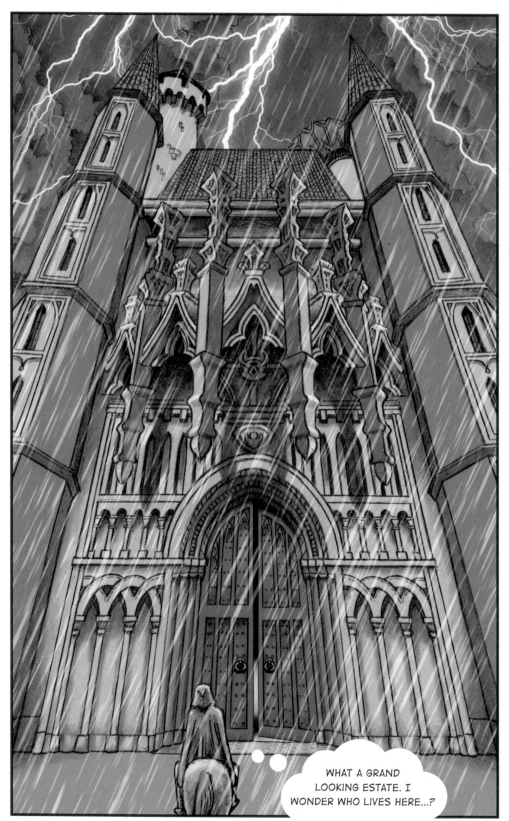

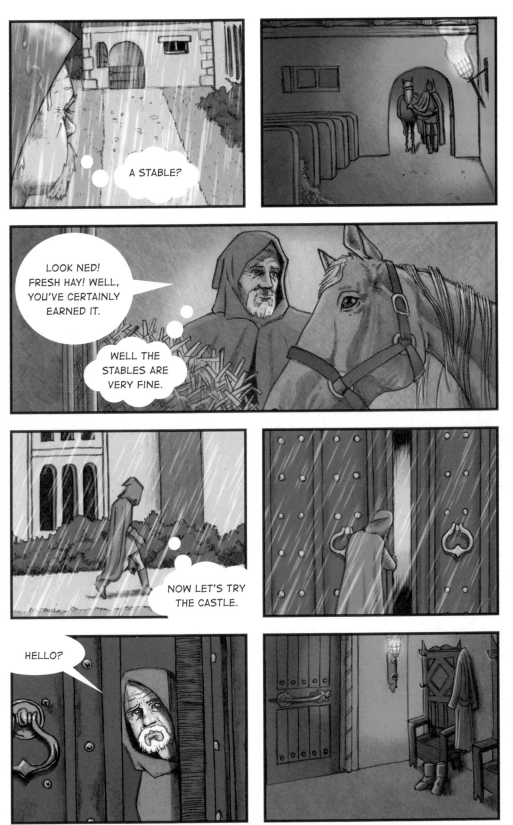

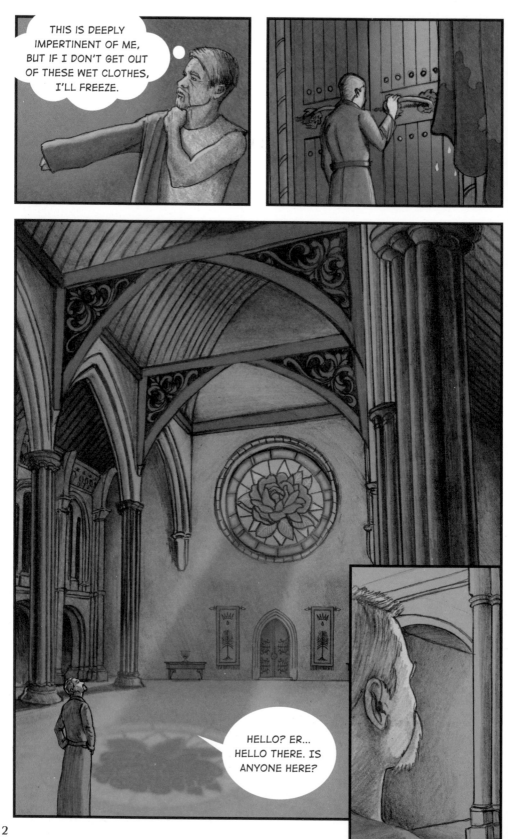

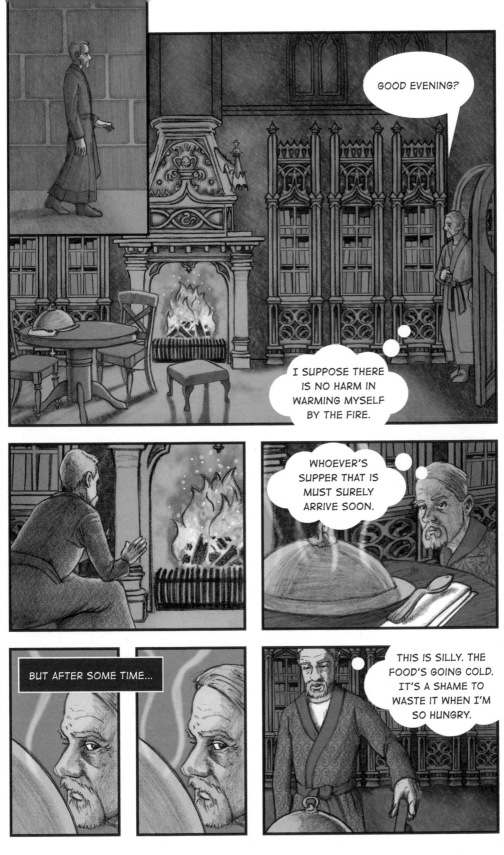

13

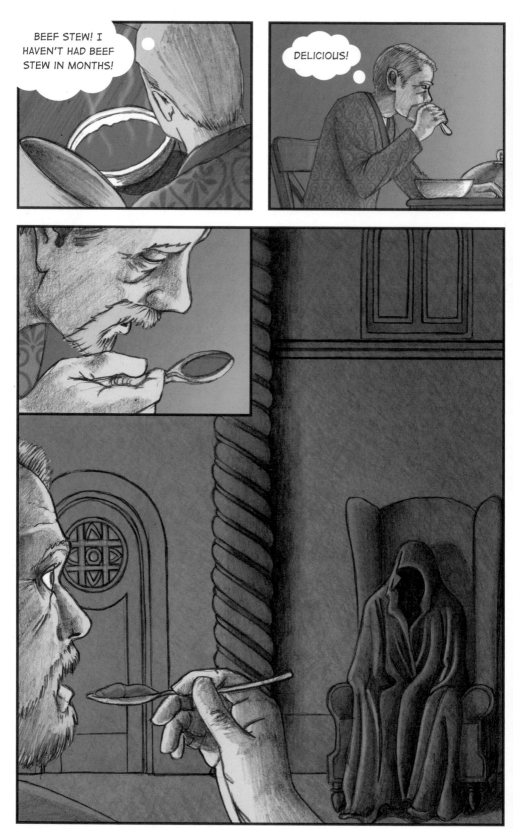

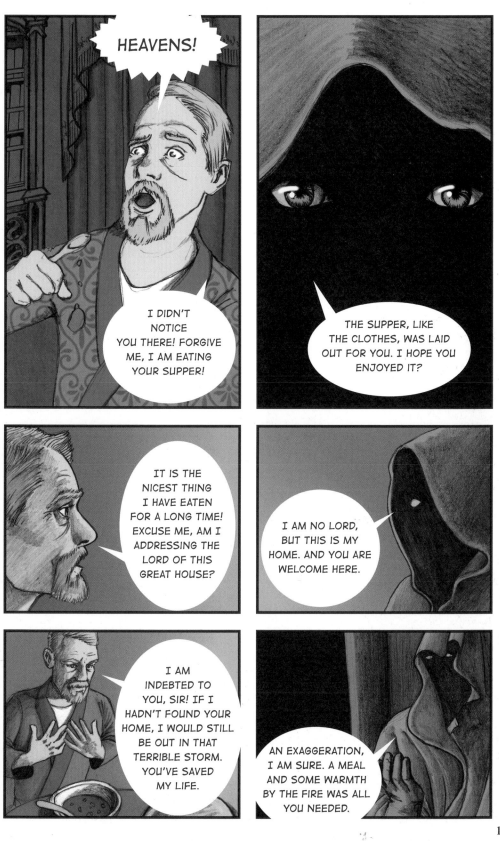

15

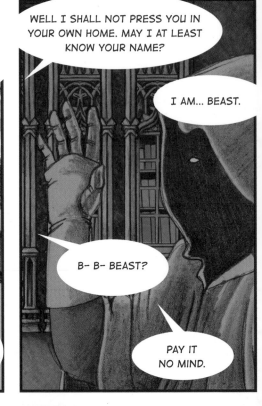

WELL, I AM TRULY GRATEFUL. COME, SIT CLOSER TO THE FIRE. I WOULD LIKE TO SEE MY SAVIOR.

WELL I SHALL NOT PRESS YOU IN YOUR OWN HOME. MAY I AT LEAST KNOW YOUR NAME?

I AM... BEAST.

B- B- BEAST?

I WILL REMAIN HERE. I AM CURRENTLY SUFFERING UNDER A... CONDITION, WHICH HAS LEFT ME RATHER GRUESOME TO BEHOLD. I WOULD NOT WANT TO SCARE YOU.

PAY IT NO MIND.

LIKE ALL UNFORTUNATE NAMES, IT WAS FORCED UPON ME. WHO ARE YOU, FRIEND, AND WHAT BRINGS YOU HERE?

MY NAME IS EMERY TIBON AND IT IS A LONG, MISERABLE STORY THAT LED ME TO YOUR DOOR.

WELL, MASTER TIBON, I RARELY HAVE COMPANY. I WOULD BE HONORED IF YOU WOULD INDULGE ME.

IF YOU INSIST. I WOULD NOT REFUSE SO GRACIOUS A HOST.

THERE IS A TALE TOLD AROUND OAKBRIDGE ABOUT A ONCE-RICH AND NOTABLE FAMILY. THE FATHER WAS A SUCCESSFUL MAN AND THE MOTHER WAS A DISTANT RELATION OF SOME FORGOTTEN DUKE. THIS THIN STRAND OF NOBILITY GAVE HER AIRS AND FANCIFUL IDEAS. SO MUCH SO, THAT SHE GRANDLY NAMED THEIR THREE CHILDREN CHARITY, VALOR, AND BEAUTY.

CHARITY AND HER BROTHER, VALOR, THOUGHT THEMSELVES VERY GRAND INDEED. THEIR MOTHER HAD RAISED THEM ON A DIET OF PAMPERING AND UNDESERVED PRAISE THAT HAD MADE THEM LAZY, ARROGANT, COLD, AND CRUEL. DESPITE THESE FAULTS THEY HAD MANY ADMIRERS, BUT THE SIBLINGS TREATED THEM WITH THE SAME DISDAIN THEY SHOWED FOR EVERYONE ELSE.

BEAUTY, ON THE OTHER HAND, WAS NOT LIKE HER OLDER SIBLINGS. MANY THOUGHT THIS WAS DUE TO HER MOTHER DYING SOON AFTER GIVING BIRTH TO HER. WHILE SAD, THIS MEANT BEAUTY WAS LUCKY ENOUGH TO ESCAPE HER MOTHER'S INFLUENCE AND WAS RAISED BY HER FATHER AND A LOCAL NURSEMAID.

THIS MORE HUMBLE UPBRINGING MEANT BEAUTY WAS EVERYTHING HER SIBLINGS WERE NOT. WHILE CHARITY AND VALOR LIKED REVELING AND SPENDING MONEY, BEAUTY SPENT TIME AT HOME READING AND PRACTICING WITH HER BOW. SHE WAS MODEST, KIND, AND HARD WORKING. SHE LIKED HER OWN COMPANY, BUT ALWAYS MADE TIME FOR PEOPLE, AND WAS WARM AND FRIENDLY TO ALL.

THE FATHER HAD MADE HIS FORTUNE IN TRADE. HE HAD THREE SHIPS THAT CONTINUOUSLY TRAVELED BACK AND FORTH FROM THE EAST. HE SENT WOOD AND WINE THERE AND BROUGHT BACK JEWELRY AND SILKS.

THEN ONE DAY, DISASTER STRUCK. A GREAT STORM DESTROYED ALL THREE OF HIS SHIPS. ALL HIS FORTUNE LAY AT THE BOTTOM OF THE SEA. WITHOUT A SHIP TO CARRY CARGO, HE COULD NO LONGER TRADE. HE WAS RUINED.

THE SUPPLIERS WHO WERE DUE PAYMENT CLAIMED ALMOST EVERYTHING. LUCKILY, THE FAMILY OWNED A SMALL HOUSE IN THE COUNTRY VERY FAR FROM TOWN. IT WAS IN HIS LATE WIFE'S NAME, SO IT WAS SAFE FROM THE DEBTORS. THIS WAS TO BE THEIR NEW HOME.

BUT CHARITY AND VALOR WERE UNHAPPY AND REFUSED TO GO. CHARITY SAID:
"WHAT WILL WE DO OUT IN THE COUNTRY? THERE ARE NO BALLS OR PARTIES. DO YOU EXPECT US TO DANCE WITH RATS AND FOXES?"

HER FATHER REPLIED:
"THERE WILL NOT BE TIME FOR DANCING WITH ALL THE WORK THAT NEEDS DOING."
VALOR WAS SHOCKED.
"WORK?! ARE YOU MAD? WE DO NOT 'WORK.' WE HAVE MANY ADMIRERS HERE. THEY WILL BE MORE THAN HAPPY TO MARRY US OR PROVIDE FOR US. YOU TWO CAN GO AND LIVE LIKE HERMITS IN THAT HOVEL."

BUT WHEN CHARITY AND VALOR VISITED THEIR FORMER FRIENDS, THEY FOUND THEM FAR LESS ACCOMMODATING THAN THEY ONCE WERE. WITHOUT THEIR CONSIDERABLE ALLOWANCE FROM THEIR FATHER, THE SIBLINGS' APPEAL WAS MUCH DIMINISHED. ALL THEIR CONCEITED BEHAVIOR, OLD SLIGHTS, AND UGLY WORDS WERE SUDDENLY REMEMBERED, AND THEY WERE MOST DEFINITELY NO LONGER WELCOME.

BEAUTY, ON THE OTHER HAND, HAD OFFERS FROM A NUMBER OF FAMILIES WILLING TO TAKE HER IN, BUT SHE WOULD NOT DESERT HER FATHER AT THAT DIFFICULT TIME.

SO, WITH NO OTHER COURSE OPEN TO THEM, THE FAMILY PACKED UP THEIR REMAINING POSSESSIONS AND RELOCATED TO THEIR NEW, REMOTE HOME. PEOPLE FELT VERY SAD FOR BEAUTY'S MISFORTUNE, BUT WERE WELL PLEASED AT SEEING CHARITY AND VALOR RECEIVING THEIR "JUST DESERTS." THEY WERE HAPPY TO SEE THEM OFF. AND IT WAS A NUMBER OF YEARS BEFORE ANYONE HEARD ANYTHING OF THE FAMILY AGAIN.

CHAPTER
~ TWO ~

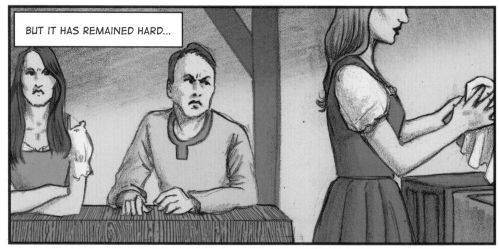

SO WE MOVED TO THE COUNTRY. IT WAS DIFFICULT AT FIRST. WE HAD NO EXPERIENCE IN GROWING FOOD OR LOOKING AFTER ANIMALS.

MY TWO ELDEST HAD NEVER EVEN CLEANED UP AFTER THEMSELVES BEFORE. IT PROVED IMPOSSIBLE TO GET THEM TO DO ANYTHING. THEY SULKED IN THEIR ROOMS AND ONLY APPEARED AT MEALTIMES.

BETWEEN MYSELF AND BEAUTY WE MANAGED TO GET THE HOUSE AND LAND IN ORDER AND EKED OUT WHAT PRODUCE WE COULD...

BUT IT HAS REMAINED HARD...

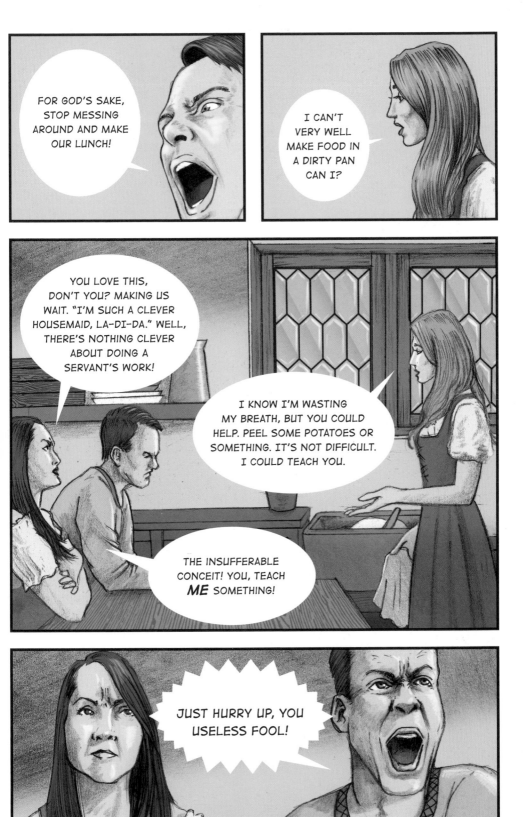

÷SIGH÷

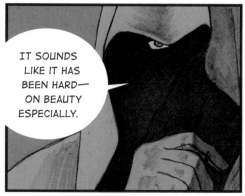

IT SOUNDS LIKE IT HAS BEEN HARD— ON BEAUTY ESPECIALLY.

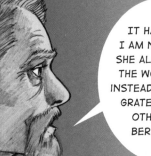

IT HAS. WHEN I AM NOT THERE, SHE ALONE DOES THE WORK. AND INSTEAD OF BEING GRATEFUL, THE OTHER TWO BERATE HER.

IT IS MY FAULT, OF COURSE, LETTING THEM BE INDULGED AS CHILDREN. AND IT IS ALL TOO OBVIOUS THAT BEAUTY IS MY FAVORITE, WHICH JUST MAKES THEM HATE HER MORE. POOR UNFORTUNATE GIRL.

YOU ARE AWAY FROM HOME OFTEN, THEN?

I RIDE EVERY WEEK TO A SMALL VILLAGE...

IT'S A ROUGH SORT OF PLACE, BUT IT HAS AN INN AND TWO SHOPS. BETWEEN THE THREE BUSINESSES, I GET THREE DAYS' WORK A WEEK BOOKKEEPING, SERVING, THAT SORT OF THING.

WITH THE DAY'S RIDE THERE AND BACK, I'M GONE FOR ALMOST FIVE DAYS EVERY WEEK. I HATE TO LEAVE BEAUTY ALONE WITH THE OTHER TWO, BUT WE DESPERATELY NEED THE INCOME.

IT SOUNDS LIKE SOME PUNISHMENT IS IN ORDER.

I HAVE OFTEN THOUGHT ON IT. BUT I KNOW THAT IF I WERE TO PUNISH THEM, THEY WOULD TAKE THEIR REVENGE OUT ON BEAUTY.

FOR TWO YEARS, WE HAVE LIVED THIS UNCHANGING, MEAGER EXISTENCE. UNTIL A NUMBER OF WEEKS AGO, THAT IS...

I RECEIVED AN UNEXPECTED LETTER FROM THE CAPTAIN OF ONE OF MY SHIPS! HE HAD SURVIVED THE STORM AND HAD BEEN RECOVERING IN A SECLUDED MONASTERY FOR A VERY LONG TIME.

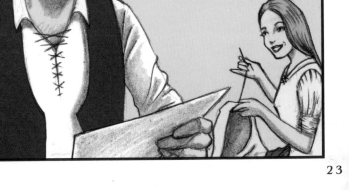

ONCE HIS SENSES HAD RETURNED TO HIM, HE WROTE TO INFORM ME THAT HE HAD IN HIS POSSESSION A FEW BOXES OF MY EASTERN JEWELRY, WHICH HE FELT OBLIGATED TO RETURN TO ME.

WHETHER THIS WAS HIS OWN GOOD CHARACTER OR THE INFLUENCE OF THE MONKS WHO ATTENDED HIM, I CANNOT SAY, BUT I WELCOMED THE GOOD NEWS.

NOT QUITE AS MUCH AS MY TWO ELDEST, THOUGH...

AT LAST, WE CAN LEAVE THIS FILTHY HOLE AND RETURN TO OAKBRIDGE!

FROM WHAT I UNDERSTAND, THERE WON'T BE NEARLY ENOUGH FOR US TO DO THAT, SON. BUT IT WILL MEAN WE CAN LIVE A BIT EASIER FOR A WHILE. AND I DARESAY I CAN TREAT YOU ALL TO SOMETHING ON MY WAY BACK.

OH YES, PAPA! YES! A NEW GOWN WOULD BE WONDERFUL. EVERYTHING I WEAR IS RAGS!

AND SOME CALFSKIN BOOTS! THESE HORRIBLE, HEAVY WORK BOOTS ARE TORTURING MY POOR FEET.

24

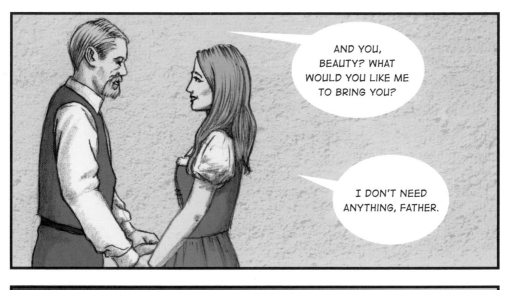

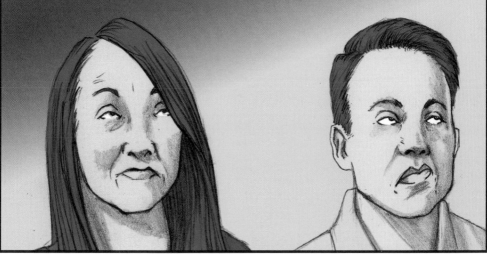

COME, I WANT TO TREAT YOU ALL.

WELL, THIS MAY SOUND SILLY, BUT I MISS THE ROSES THAT GREW AROUND OAKBRIDGE. I HAVEN'T SEEN A ROSE SINCE WE MOVED. THEY DON'T SEEM TO GROW IN THESE PARTS.

AS YOU'RE TRAVELING SO FAR, IF YOU COME ACROSS ANY, PLEASE PICK ONE FOR ME.

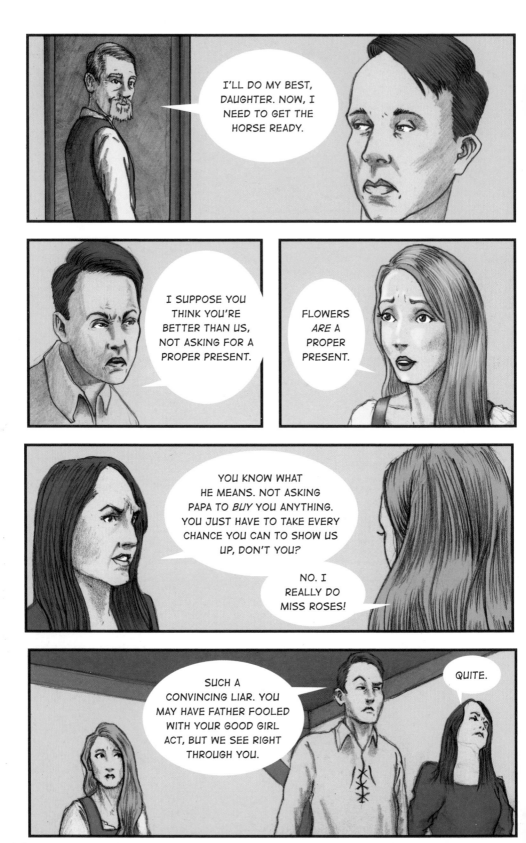

I HAD SUCH HIGH HOPES ON THE JOURNEY TO THE MONASTERY. I MADE SILLY PLANS TO START A SMALL BUSINESS THAT MIGHT PUT US BACK ON THE ROAD TO SUCCESS.

BUT MY HOPES WERE DASHED. UPON ARRIVING AT THE MONASTERY, I LEARNED THAT THE CAPTAIN HAD WRITTEN TO HIS SISTER IN OAKBRIDGE, TELLING HER OF HIS SURVIVAL.

WORD HAD SPREAD TO MY REMAINING DEBTORS THERE AND THEY HAD BEATEN ME TO THE MONASTERY, TAKING EVERYTHING THAT REMAINED OF MY WEALTH.

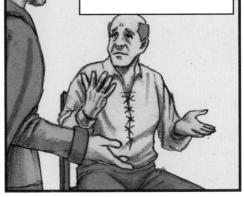

I AM A FOOL. *OF COURSE*, THE CAPTAIN WOULD WRITE AND TELL HIS SISTER HE WAS ALIVE. AND *OF COURSE* SHE WOULD TELL EVERYONE SHE KNEW IN OAKBRIDGE HER HAPPY NEWS. BUT THIS HAD NOT OCCURRED TO ME. I WAS TOO WRAPPED UP IN FANTASIES.

SO I MADE MY WAY HOME WITH NEITHER MONEY NOR PRESENTS, WONDERING HOW I WAS GOING TO FACE THE DISAPPOINTMENT OF MY CHILDREN. I HAD ALL BUT RUN OUT OF FOOD AND WAS DREADFULLY TIRED. I GOT CAUGHT IN THAT STORM, AND IF NOT FOR YOUR KINDNESS, I MAY HAVE PERISHED. YOU SAVED ME, AND I THANK YOU AGAIN.

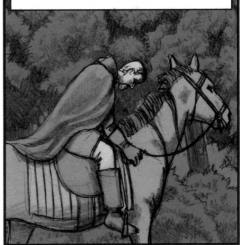

28

29

A SHAME. MY DAUGHTER WOULD LOVE ANY ONE OF THESE.

ALAS, I CANNOT ALLOW YOU TO TAKE ONE OF THESE SPECIMENS FOR HER. I MUST INSIST ON THAT. ANY ONE OF THESE COULD HOLD THE RARE SUBSTANCE I NEED.

THE CONSEQUENCES OF A LOW SUPPLY OF POTION MEANS GREAT DISCOMFORT FOR ME AND A HIGH RISK TO OTHERS.

I UNDERSTAND. IT WOULD HAVE BEEN GOOD TO AT LEAST GRANT THE WISH OF MY DEAR BEAUTY.

I CAN SEE YOU ARE DISAPPOINTED. LET ME RAISE YOUR SPIRITS, MASTER TIMON. I HAVE SOMETHING TO TELL YOU.

YES?

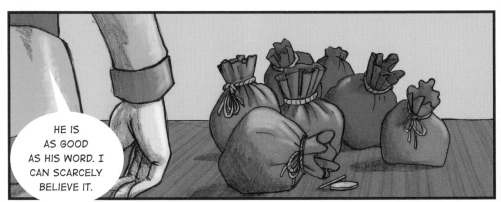

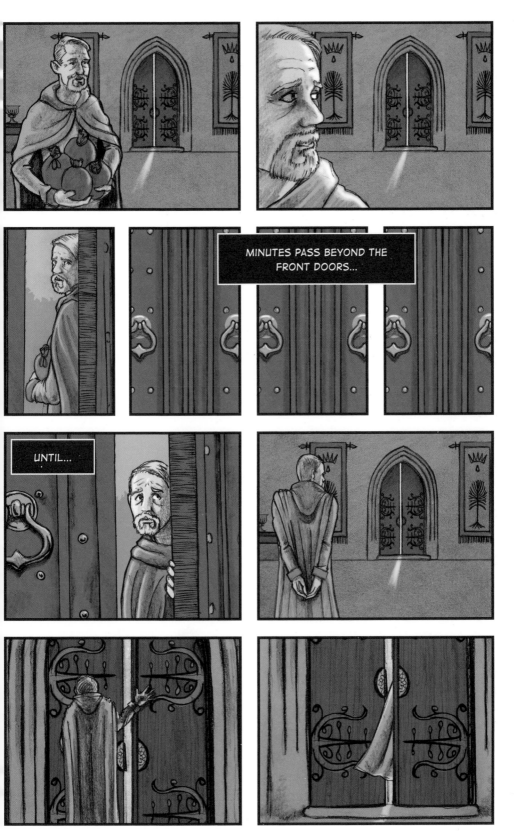

MINUTES PASS BEYOND THE
FRONT DOORS...

UNTIL...

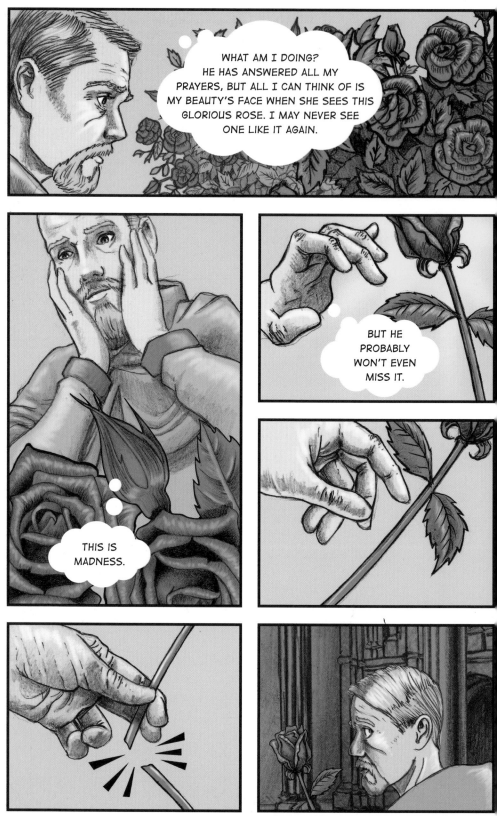

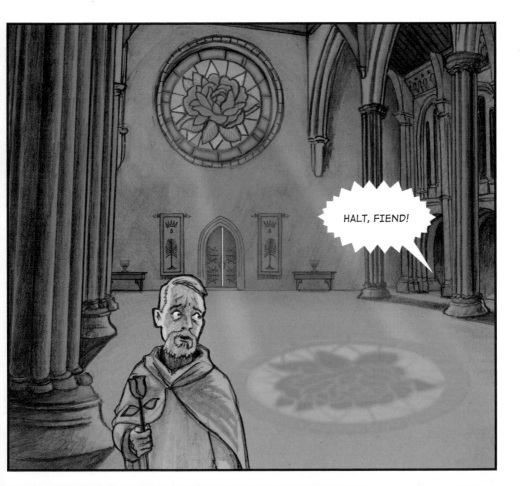

35

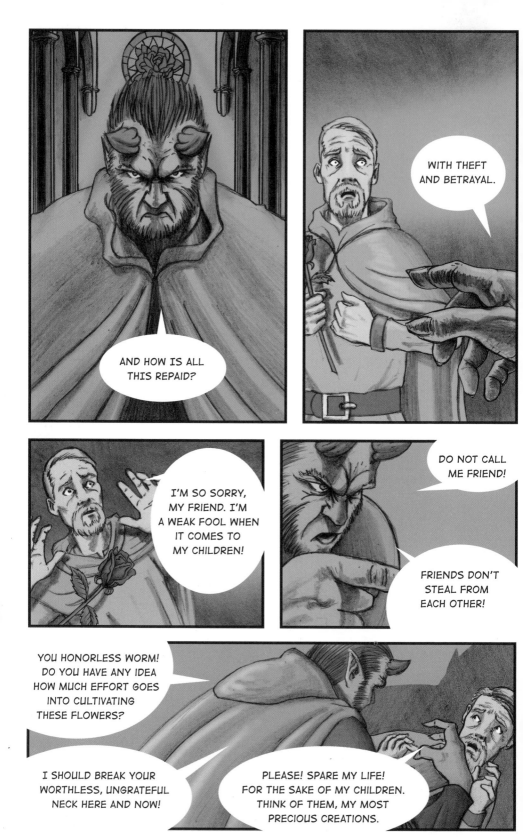

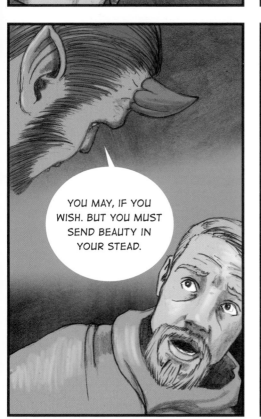

...EXCEPT PERHAPS YOUR LIBERTY.

WHAT OF MY PRECIOUS CREATION? TORN FROM THE BRANCH TO DIE?

YES. THAT'S IT. YOU WILL STAY HERE AS PAYMENT FOR YOUR CRIME. FOR AS LONG AS I SEE FIT.

PLEASE! SPARE ME.

WHY SHOULD I SPARE YOUR MISERABLE LIFE? YOU HAVE NOTHING TO OFFER...

BUT HOW WILL MY POOR FAMILY SURVIVE WITHOUT ME? YOU ARE CONDEMNING THEM TO STARVE! LET ME RETURN TO THEM, PLEASE!

SEND BEAUTY HERE AND YOU AND YOUR OTHER CHILDREN CAN REBUILD YOUR LIVES IN COMFORT. OR STAY HERE AND ALL THREE OF THEM WILL HAVE TO SUFFER, AND POSSIBLY STARVE ON THEIR OWN. THE CHOICE, "FRIEND," IS YOURS.

YOU MAY, IF YOU WISH. BUT YOU MUST SEND BEAUTY IN YOUR STEAD.

CHAPTER
~ THREE ~

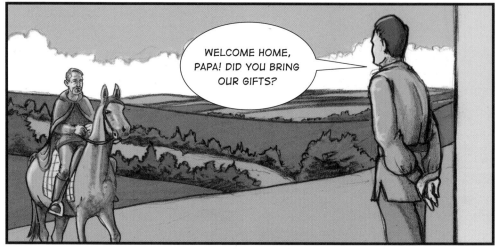

WELCOME HOME, PAPA! DID YOU BRING OUR GIFTS?

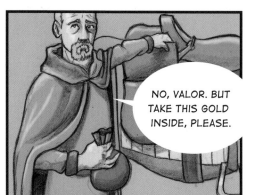

NO, VALOR. BUT TAKE THIS GOLD INSIDE, PLEASE.

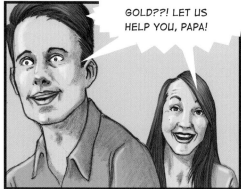

GOLD??! LET US HELP YOU, PAPA!

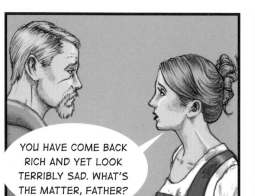

YOU HAVE COME BACK RICH AND YET LOOK TERRIBLY SAD. WHAT'S THE MATTER, FATHER?

COME INSIDE, DEAREST, AND I WILL TELL YOU ALL, INCLUDING THE COST OF THESE RICHES.

SO NOW YOU KNOW. I WAS WEAK AND SILLY. I ONLY WANTED TO FULFILL YOUR WISH BEAUTY, BUT INSTEAD I HAVE CONDEMNED YOU TO AN UNKNOWN FATE AT THE MERCY OF A MONSTER. I AM SO SORRY.

IT'S NOT YOUR FAULT, PAPA. IT IS HERS FOR ASKING FOR SUCH A SELFISH GIFT.

IF YOU'D ASKED FOR A NORMAL PRESENT LIKE A HAT OR GLOVES, THEN NONE OF THIS WOULD HAVE HAPPENED. BUT NO, AS USUAL YOU HAD TO BE SPECIAL.

HUSH, CHARITY! IT WAS MY ACTIONS THAT ANGERED THE FRIGHTENING BEAST. BUT NOW I'M HERE, AWAY FROM HIS MAGICAL INFLUENCE.

I'M CONSIDERING GOING AGAINST HIS WISHES AND EITHER NOT SENDING BEAUTY AT ALL...

...OR RETURNING MYSELF WITH THE GOLD.

TAKE BACK THE GOLD?! YOU CAN'T DO THAT, PAPA! YOU MAY ANGER HIM FURTHER! HE MAY KILL US ALL!

VALOR IS RIGHT, PAPA. LOOK HOW ANGRY HE WAS WHEN YOU DISOBEYED HIM ONCE. YOU CAN'T DEFY HIM AGAIN. YOU MUST DO AS THE MONSTER ASKS AND SEND BEAUTY.

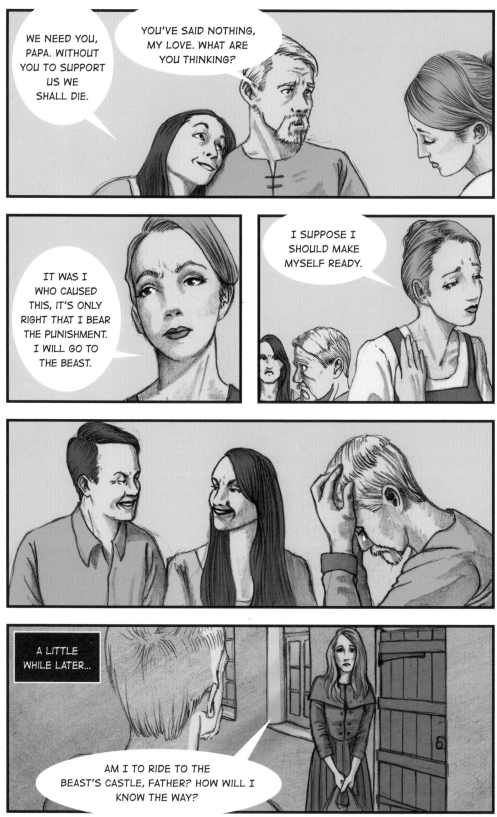

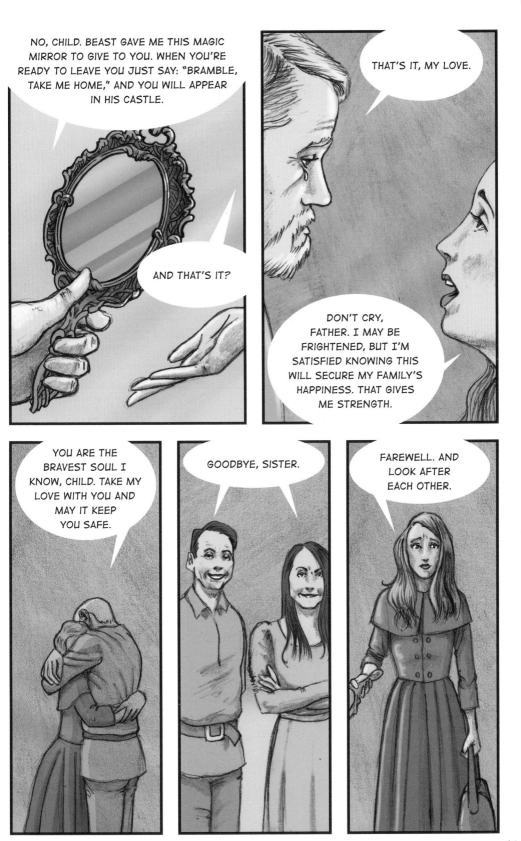

41

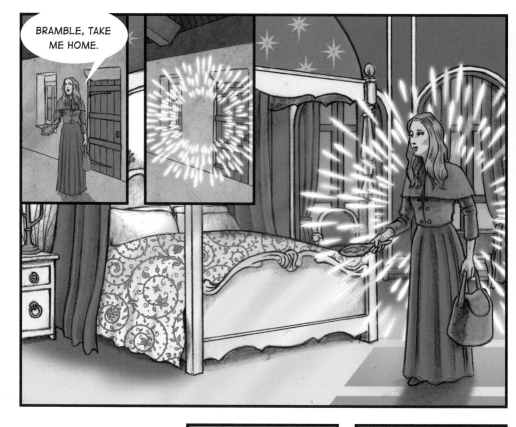

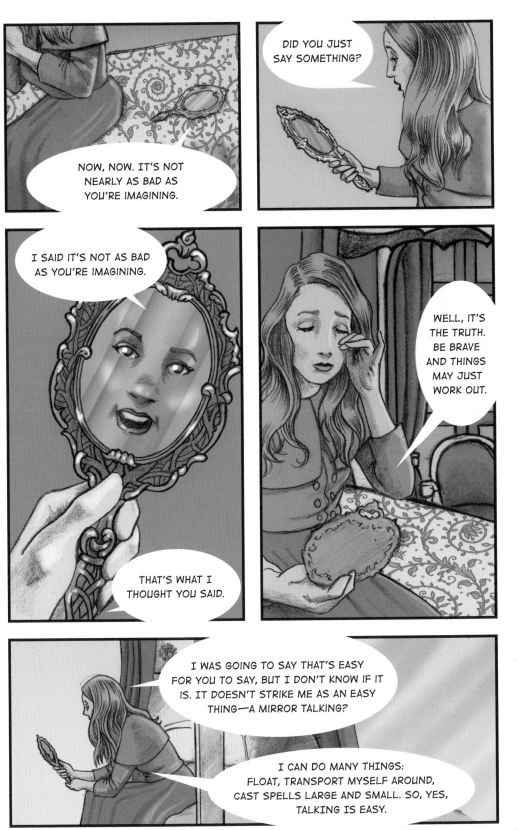

43

WHY HAVE YOU BEEN SILENT UNTIL NOW, THEN? WHY DIDN'T YOU SPEAK BACK AT MY HOME?

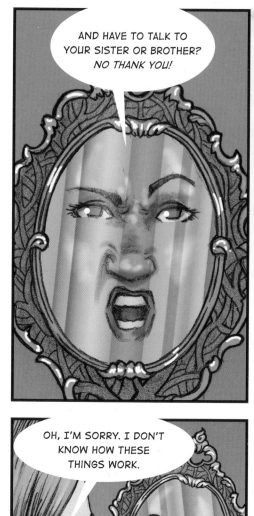

AND HAVE TO TALK TO YOUR SISTER OR BROTHER? *NO THANK YOU!*

THERE. A BIT MORE OF *THAT* AND YOU'LL START TO FEEL BETTER.

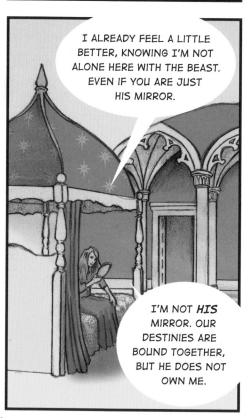

I ALREADY FEEL A LITTLE BETTER, KNOWING I'M NOT ALONE HERE WITH THE BEAST. EVEN IF YOU ARE JUST HIS MIRROR.

I'M NOT **HIS** MIRROR. OUR DESTINIES ARE BOUND TOGETHER, BUT HE DOES NOT OWN ME.

OH, I'M SORRY. I DON'T KNOW HOW THESE THINGS WORK.

IT'S ALL RIGHT. WE HAVE A UNIQUE RELATIONSHIP, I GRANT YOU.

44

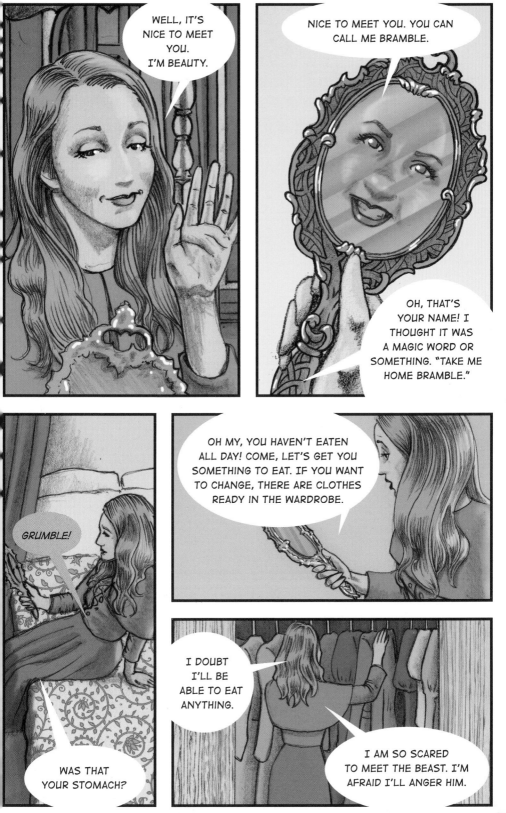

45

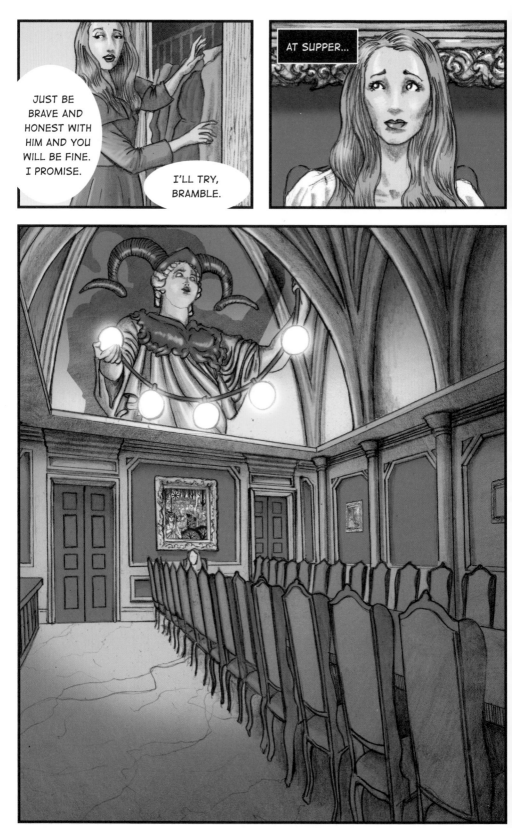

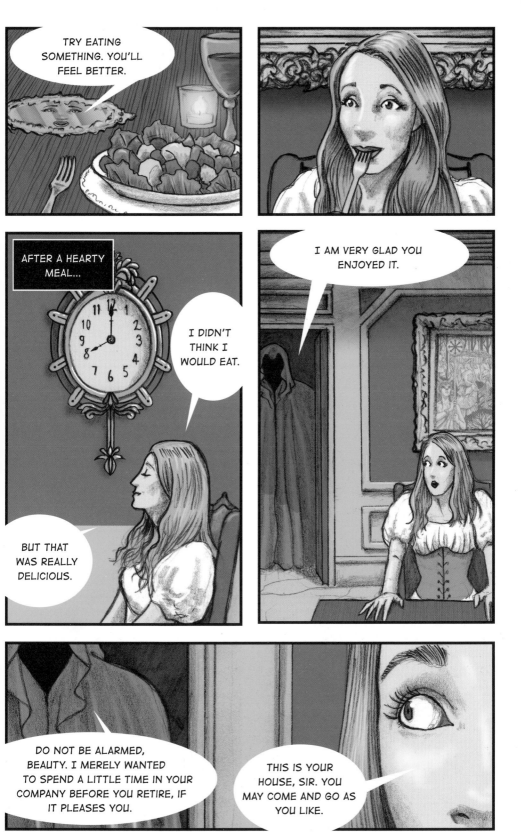

47

NOT IF IT DISPLEASES YOU. THIS IS YOUR HOUSE AS WELL NOW, AND I WOULD LIKE YOU TO BE HAPPY HERE.

FORGIVE ME FOR SAYING SO, BUT I WOULD'VE BEEN HAPPIER STAYING WITH MY FAMILY.

MAYBE, BUT WOULD YOU BE CONTENT TO LIVE ON THE MONEY I GAVE YOUR FAMILY, KNOWING YOUR FATHER DID NOT KEEP HIS WORD?

AND YOUR LIFE WASN'T ALL THAT HAPPY, FROM WHAT I UNDERSTAND. APART FROM THE LOVE OF YOUR FATHER, THERE SEEMS TO BE LITTLE AFFECTION BETWEEN YOU AND YOUR KIN.

NO, I WOULD NOT.

I WOULD GO SO FAR AS TO SAY YOU LED QUITE A MISERABLE EXISTENCE.

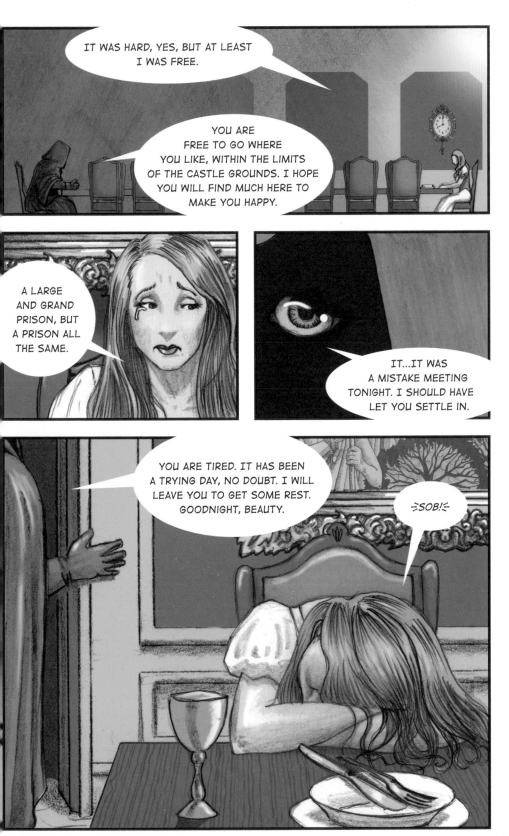

CHAPTER
~ FOUR ~

THERE IS A TALE TOLD AROUND THESE PARTS ABOUT A PRINCE. A PRINCE BOTH HANDSOME AND CLEVER, BUT PERHAPS TOO HANDSOME AND NOT QUITE CLEVER ENOUGH. THE KING AND QUEEN DOTED ON THEIR SON AND PRAISED HIM ABOVE ALL ELSE, AS DID ALL THEIR SUBJECTS. HE GREW UP KNOWING NOTHING BUT ADULATION, SO EVENTUALLY THE ONCE GOOD-NATURED CHILD GREW INTO AN ARROGANT AND UNFEELING YOUNG MAN.

WHEN HE WAS OF AGE, MANY GREAT HOUSES PRESENTED THEIR DAUGHTERS AS POSSIBLE WIVES FOR THE PRINCE. UNCONCERNED WITH MARRIAGE, HE WAS MORE INTERESTED IN BREAKING THE HEARTS AND REPUTATIONS OF THE COMMONERS OF HIS KINGDOM. HIS BAD CHARACTER BECAME WELL KNOWN, BUT HIS ABUNDANT CHARM AND GOOD LOOKS COULD SWAY THE MOST DETERMINED OF HEARTS.

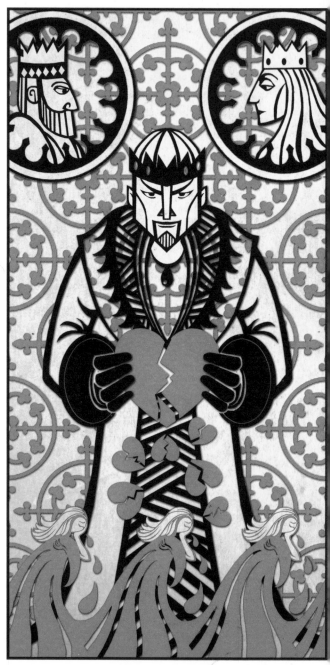

ONE SUMMER SOLSTICE, THE PRINCESS OF THE KINGDOM OF FAERIE ARRIVED WITH A DELEGATION. SHE HAD TAKEN A SHINE TO THE PRINCE AND FELT A MARRIAGE WOULD BRING THEM BOTH HAPPINESS. YET DESPITE HER FAERIE GLAMOUR, THE PRINCE BELIEVED HIMSELF TO BE SUPERIOR TO HER AND WAS RUDE AND DISMISSIVE WHEN IN HER COMPANY.

DURING THE VISIT, THE PRINCESS FOUND THE PRINCE FLIRTING WITH A SERVANT FROM HER ENTOURAGE. SHE OVERHEARD THE PRINCE SAY, "HOW COULD I LOVE A COLD, BITTER CREATURE LIKE HER? COMPARED TO YOU, COMPARED TO ME, SHE IS AN UGLY BEAST. A BEAST NO ONE COULD LOVE."

NOW, EVERYONE KNOWS IT IS UNWISE TO SHOW DISRESPECT TO FAERIES, AS THEY ARE QUICK TO ANGER. THE PRINCE'S REMARKS HAD OFFENDED THE PRINCESS GREATLY. IN A RAGE, SHE SAID TO HIM, "YOU ARROGANT, WICKED HUMAN. YOU THINK YOURSELF BETTER THAN EVERYONE! SO, I AM AN UGLY, UNLOVABLE BEAST, AM I? WELL, YOU ARE MISTAKEN, BOY. IT IS YOU WHO ARE AN UGLY BEAST, WHO WILL BE UNLOVED AND SHUNNED BY ALL."

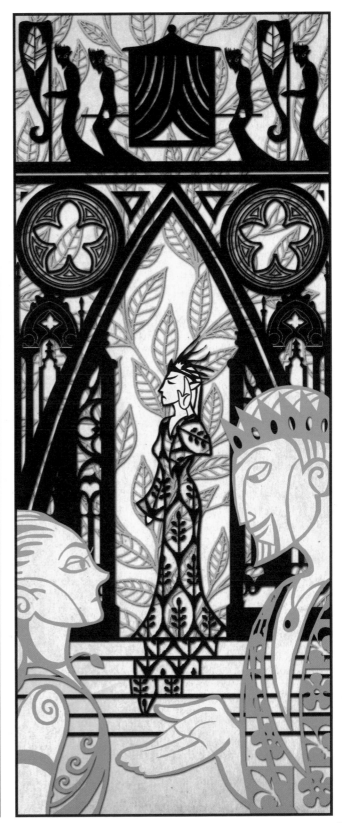

AS SHE SAID THESE WORDS, THE PRINCE TRANSFORMED INTO A HUGE, HAIRY MONSTER WITH CLAWED HANDS AND HORNS.
THE PRINCESS THEN SAID; "YOU WILL NOT AGE IN THIS FORM. YOU WILL REMAIN UNCHANGED SO THAT YOU LEARN THE ERROR OF YOUR WAYS AND REFORM YOUR WICKED CHARACTER."

"AND YOU," SAID THE PRINCESS TO HER SERVANT, "WHO IGNORES HER ROYAL DUTIES SO SHE CAN DALLY WITH MEN. IF YOU LOVE THE COMPANY OF THIS LESSER BEING SO MUCH, I CONDEMN YOU TO STAY WITH HIM. DALLY WITH HIM FOREVER! MAYBE YOU WILL BE MORE USEFUL TO HIM THAN YOU HAVE BEEN TO ME!"

AT THIS, THE POOR FAERIE SERVANT TRANSFORMED INTO A MIRROR AND WAS CONJURED INTO THE POCKET OF THE BEASTLY PRINCE.
THE PRINCESS WAS SATISFIED WITH HER WORK. SHE WAS ABOUT TO LEAVE, BUT THEN TURNED AND SAID, "THERE IS A WAY TO REMOVE MY CURSE, BOY. FIND SOMEONE TO LOVE YOU. A SPECIAL PERSON WHO, UNLIKE YOU, CAN SEE PAST A PRETTY FACE. FIND THIS PERSON, WIN THEIR HEART WITHOUT TELLING THEM WHO YOU REALLY ARE, AND MY CURSE WILL BE BROKEN."

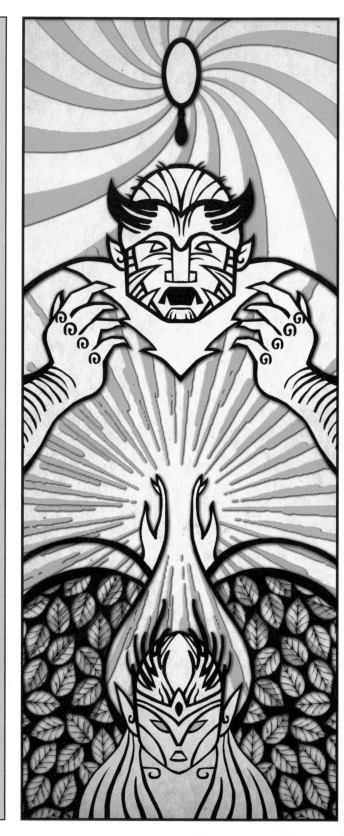

SHE THEN DISAPPEARED
WITH HER ENTOURAGE,
LEAVING THE
PRINCE ALONE.
THE PRINCE RAN TO TELL
HIS PARENTS WHAT HAD
HAPPENED, BUT FOUND HE
COULD NOT SPEAK, ONLY
GROWL AND ROAR.

THE KING, QUEEN, AND
EVERYONE WHO SAW HIM
THOUGHT A WILD MONSTER
HAD SOMEHOW GOTTEN
INTO THE CASTLE. THE
GUARDS ATTACKED THE
PRINCE AND CHASED
HIM FROM THE
CASTLE GROUNDS.

AS THE HOURS PASSED
AND THE PRINCE COULD
NOT BE FOUND, IT WAS
BELIEVED HE HAD BEEN
EATEN BY THE MONSTER.
A GREAT HUNT WAS
ORGANIZED TO KILL THE
BEAST. THE PRINCE HAD
NO CHOICE BUT TO FLEE
HIS BIRTH LANDS AND
ONLY HOPE THAT ONE
DAY HE MIGHT RETURN,
SHOULD THE CURSE EVER
BE LIFTED.

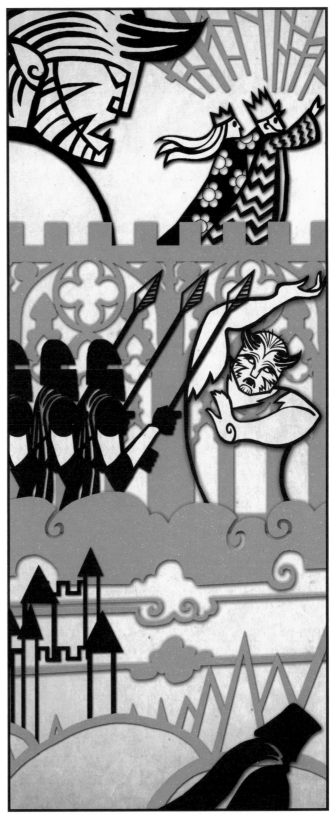

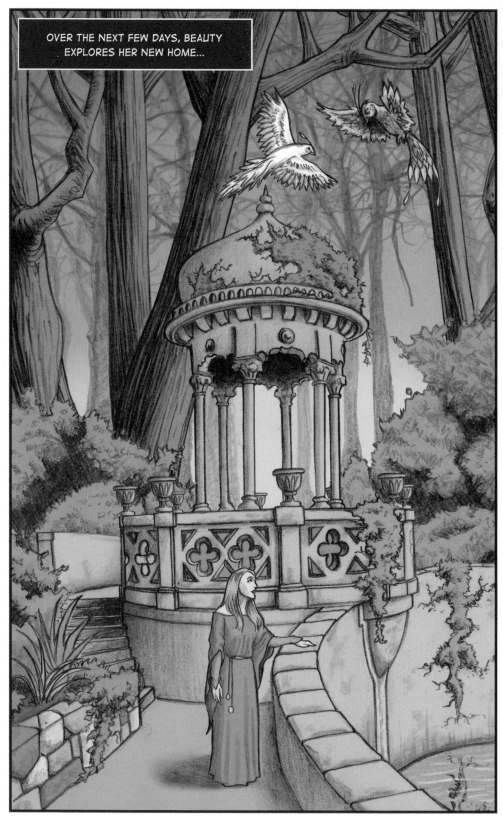

OVER THE NEXT FEW DAYS, BEAUTY EXPLORES HER NEW HOME...

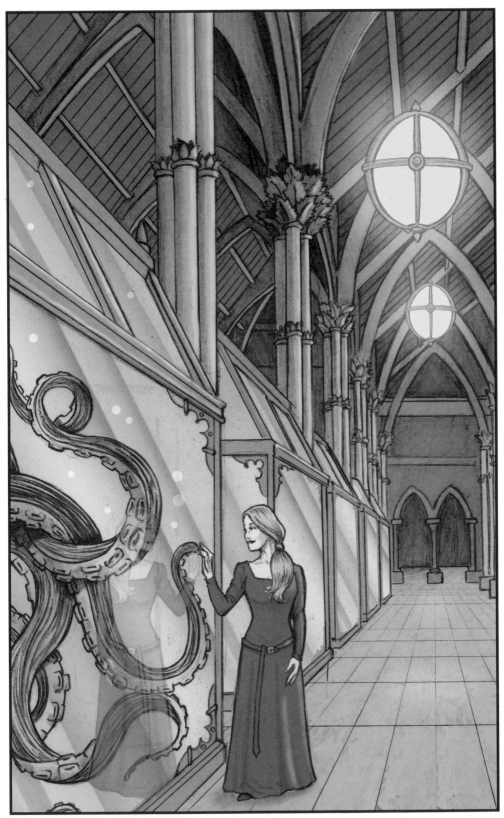

ONE EVENING...

MAY I JOIN YOU?

YES.

HOW ARE YOU THIS EVENING? YOU SEEM IN BETTER SPIRITS.

I AM FEELING A LITTLE BETTER, THANK YOU. I THINK IT WOULD BE HARD FOR ANYONE TO STAY MISERABLE IN THIS BEAUTIFUL PLACE.

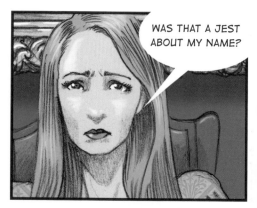

THERE IS VASTLY MORE BEAUTY HERE SINCE YOU ARRIVED.

WAS THAT A JEST ABOUT MY NAME?

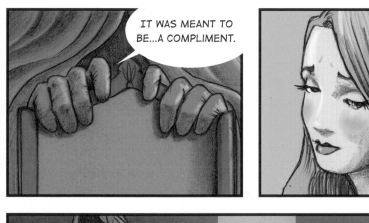

IT WAS MEANT TO BE...A COMPLIMENT.

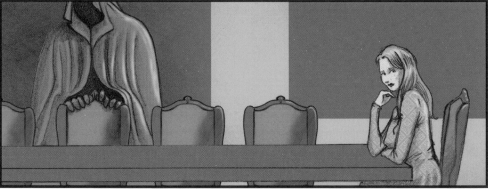

I AM GLAD YOU LIKE THE CASTLE. IT DOES HOLD MANY DELIGHTS. I WOULD TELL YOU OF THEM ALL, BUT I THINK YOU SHOULD FIND THEM OUT FOR YOURSELF. AS I DID.

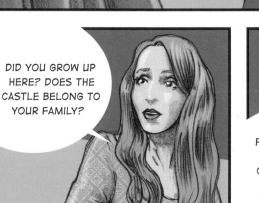

DID YOU GROW UP HERE? DOES THE CASTLE BELONG TO YOUR FAMILY?

NO, I GREW UP FAR FROM HERE. I AM SIMPLY THE CASTLE'S CURRENT OCCUPANT, BUT I'VE LIVED HERE FOR MANY YEARS.

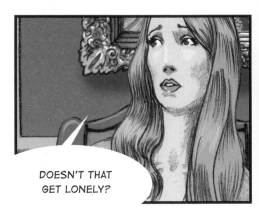

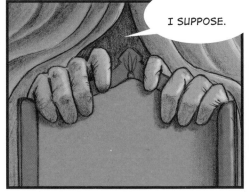

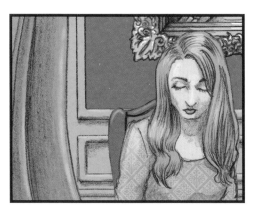

58

I DID NOTHING OF THE SORT! YOUR FATHER ACTED ON HIS OWN!

AND IF YOU KNEW ME AT ALL, MY LADY, YOU WOULD NOT THINK ME SO LOW!

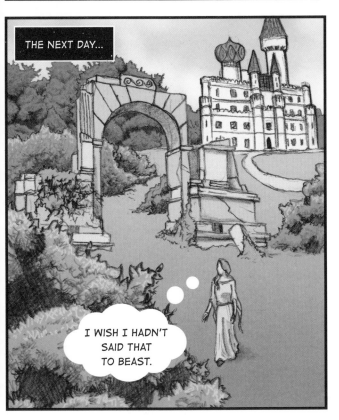

THE NEXT DAY...

I WISH I HADN'T SAID THAT TO BEAST.

I'LL APOLOGIZE TONIGHT.

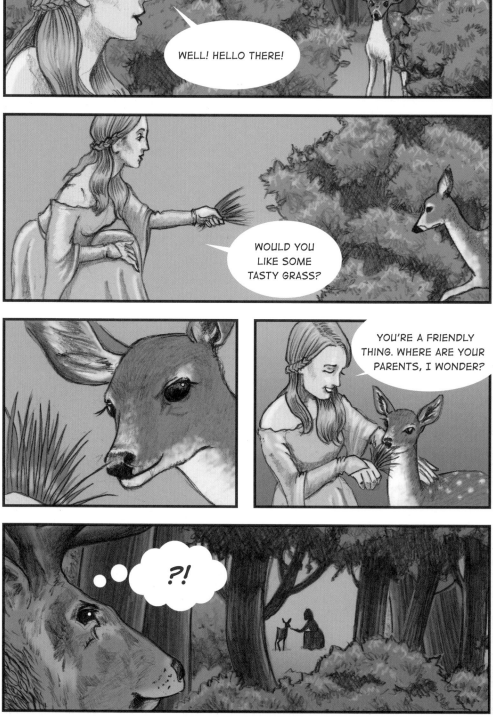

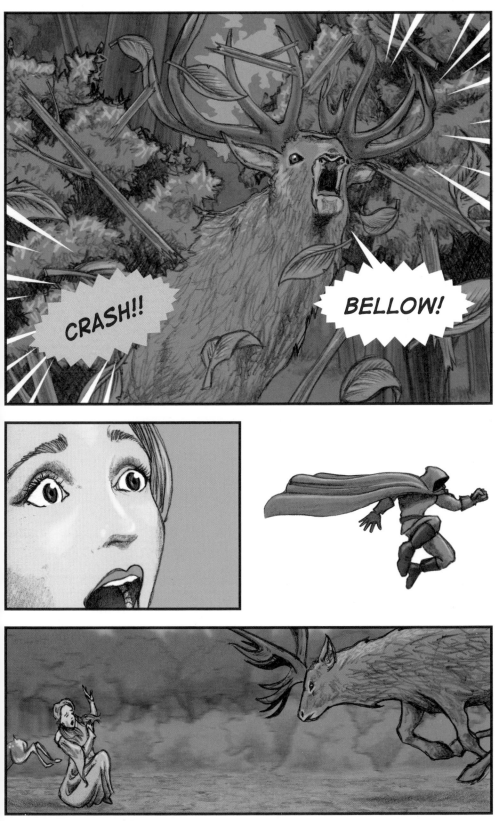

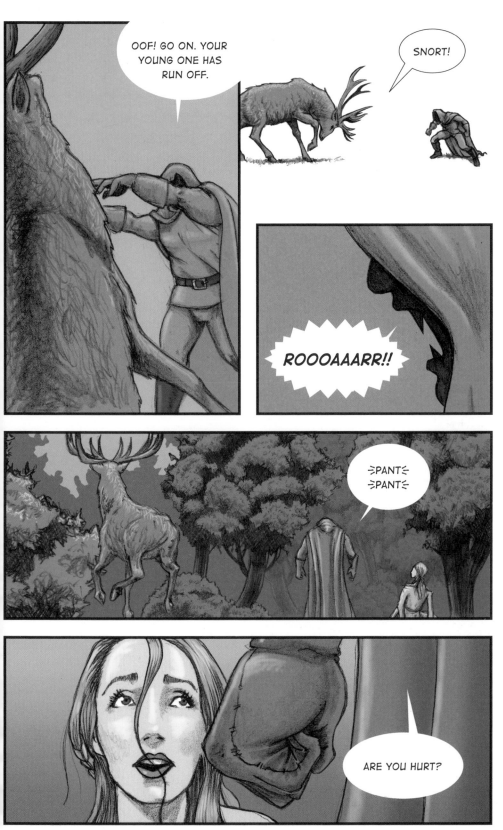

63

NO, THANKS TO YOU. YOU SAVED ME! I'VE NEVER SEEN A STAG SO LAR—

YOU WOULD DO WELL IN THE FUTURE NOT TO WANDER SO CLOSE TO THE WOODS!

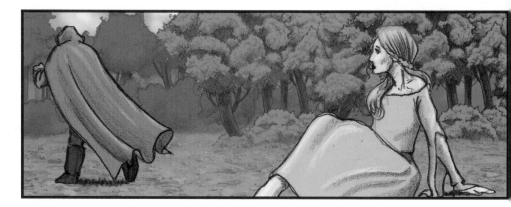

THAT EVENING...

IS BEAST NOT COMING THIS EVENING?

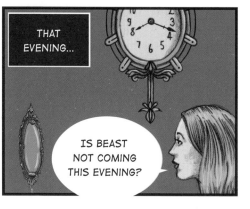

I DON'T THINK SO. HE WAS MIGHTILY UPSET BY WHAT YOU SAID LAST NIGHT.

OH...

BRAMBLE, CAN YOU TELL HIM THAT I'M SORRY? I HAVE NO WISH TO OFFEND HIM. ESPECIALLY AFTER HE SAVED ME FROM THE GIANT STAG TODAY.

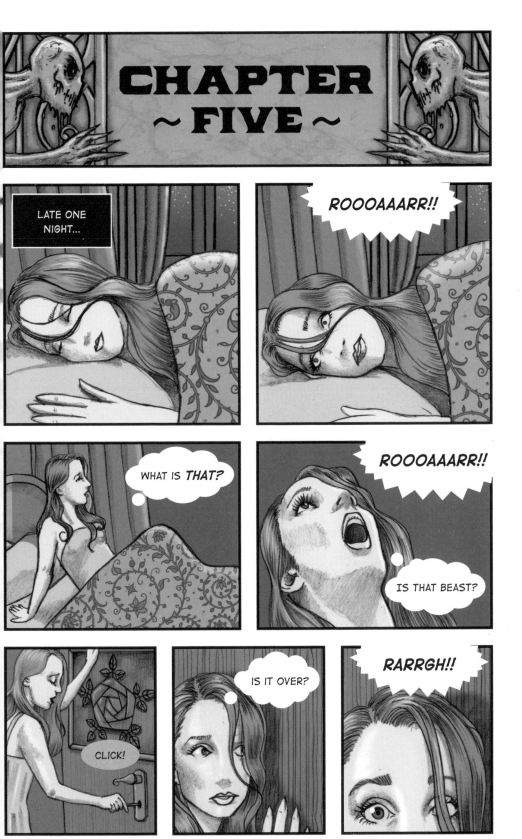

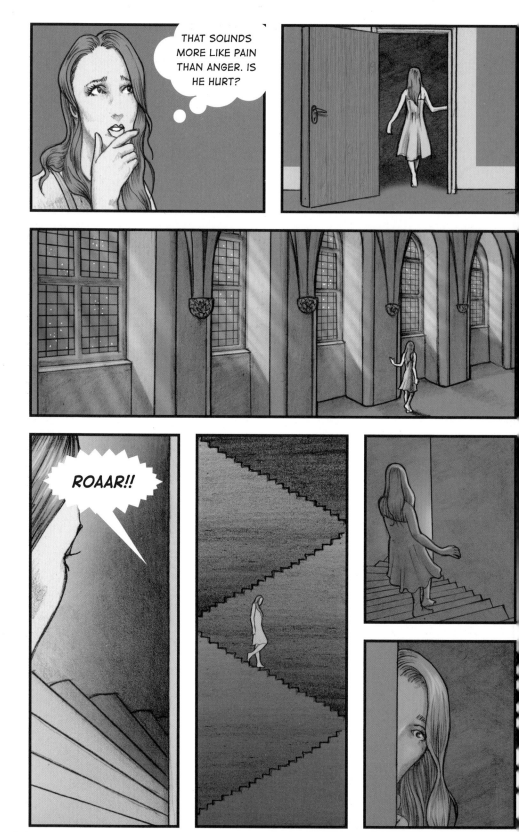

66

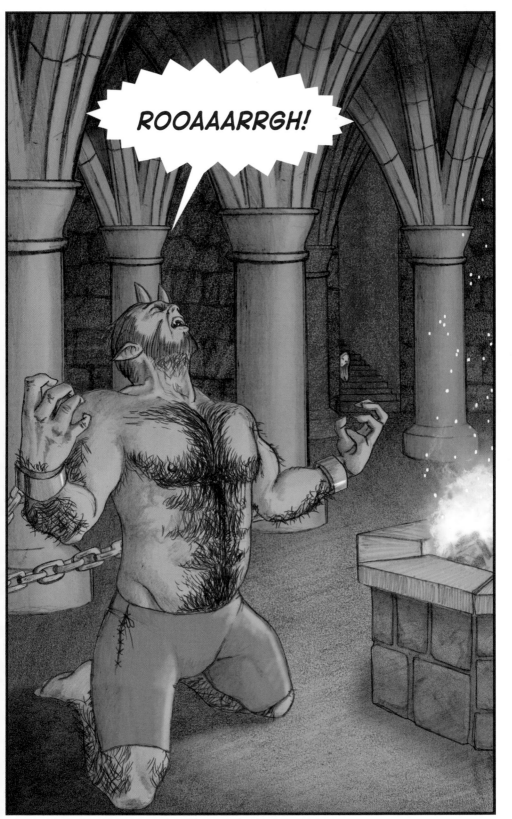

BEAUTY! COME AWAY! HE'D BE SO DISTRESSED TO KNOW YOU'D WITNESSED THIS!

I'M NOT SURE WHAT I *AM* WITNESSING.

PLEASE, BEAUTY, COME AWAY AND I'LL TELL YOU WHAT I CAN.

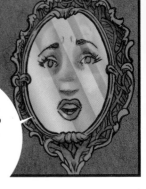

BACK UPSTAIRS...

BEAST IS CURSED. AND NOW YOU HAVE SEEN HOW. WHEN IT FIRST HAPPENED, HE WAS MUCH LIKE THE WILD ANIMAL YOU SAW.

IT TOOK A LONG TIME, BUT WITH MY HELP, AND THE HELP OF A POTION WE CREATED, HE EVENTUALLY LEARNED TO LIVE MORE AS A MAN.

BUT HE CANNOT ENTIRELY ESCAPE WHAT HE IS. THE POTION HELPS KEEP THE FEROCIOUS BEAST BURIED DEEP, BUT EVERY SO OFTEN THE TRUE ANIMAL CLAWS ITS WAY OUT.

IN THIS STATE HE HAS NO AWARENESS OF HIMSELF AND COULD EASILY KILL SOMETHING OR SOMEONE.

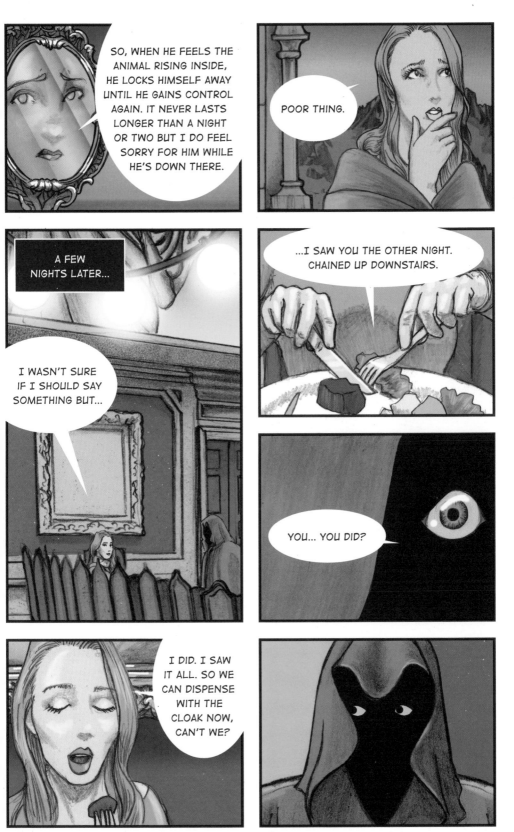

69

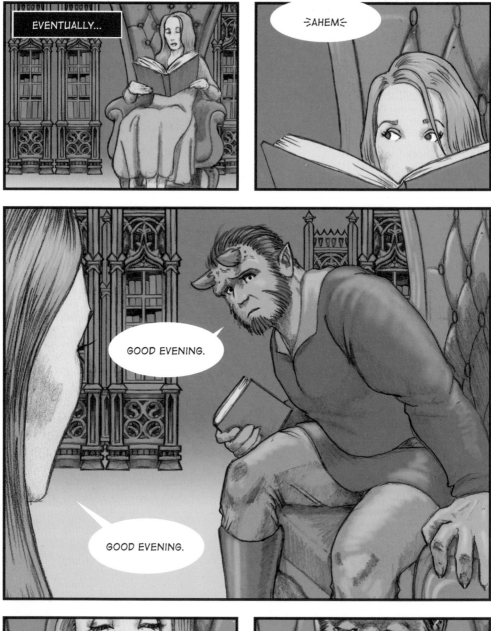

EVENTUALLY...

⋛AHEM⋚

GOOD EVENING.

GOOD EVENING.

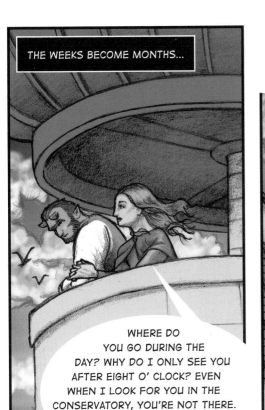

I LET YOU HAVE YOUR DAYS TO YOURSELF SO I'M NOT CONSTANTLY FORCING MY COMPANY ON YOU.

WHERE DO YOU GO DURING THE DAY? WHY DO I ONLY SEE YOU AFTER EIGHT O' CLOCK? EVEN WHEN I LOOK FOR YOU IN THE CONSERVATORY, YOU'RE NOT THERE.

TRADITIONALLY, EIGHT O' CLOCK IS THE SOCIAL HOUR. NOT TOO EARLY TO INTERRUPT SUPPER AND NOT TOO LATE TO INTRUDE.

THAT'S VERY CONSIDERATE OF YOU, BUT FORGET ABOUT TRADITION. IT'S RIDICULOUS TO AVOID ME ALL DAY WHEN THERE'S ONLY BRAMBLE, YOU, AND ME HERE. IT'S YOUR HOME, AFTER ALL.

BESIDES, BREAKFAST AND LUNCH HAVE BECOME TERRIBLY DULL ON MY OWN, SO LET'S HAVE NO MORE OF THAT TRADITION, PLEASE.

AS YOU WISH, MY LADY.

71

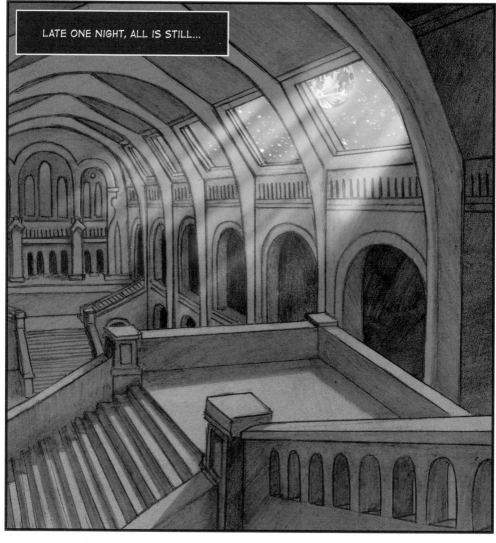

LATE ONE NIGHT, ALL IS STILL...

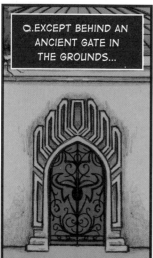

Q.EXCEPT BEHIND AN ANCIENT GATE IN THE GROUNDS...

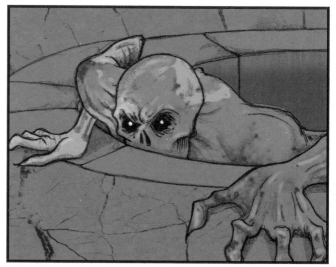

72

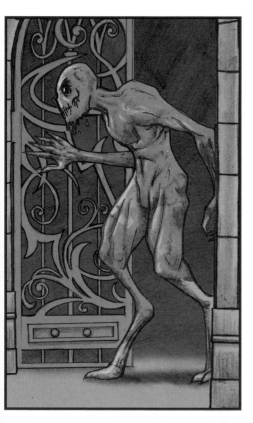

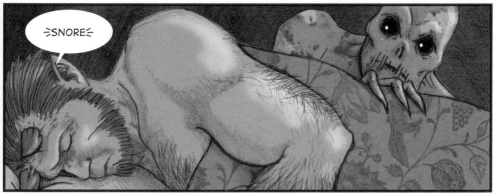
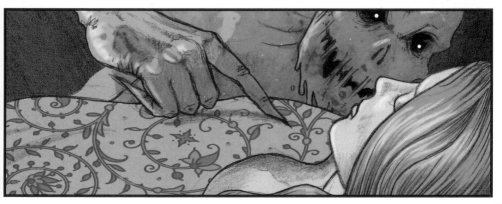

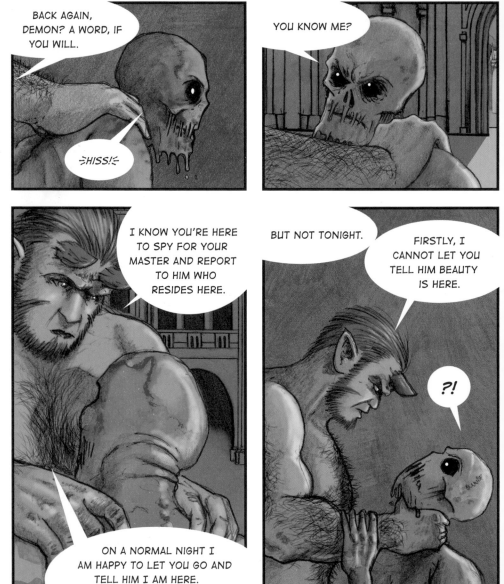

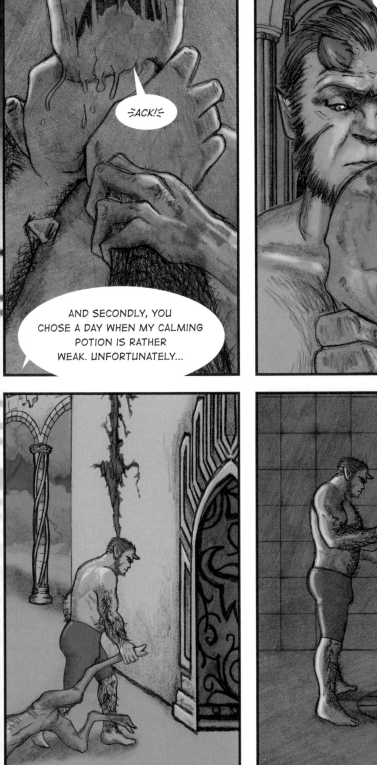

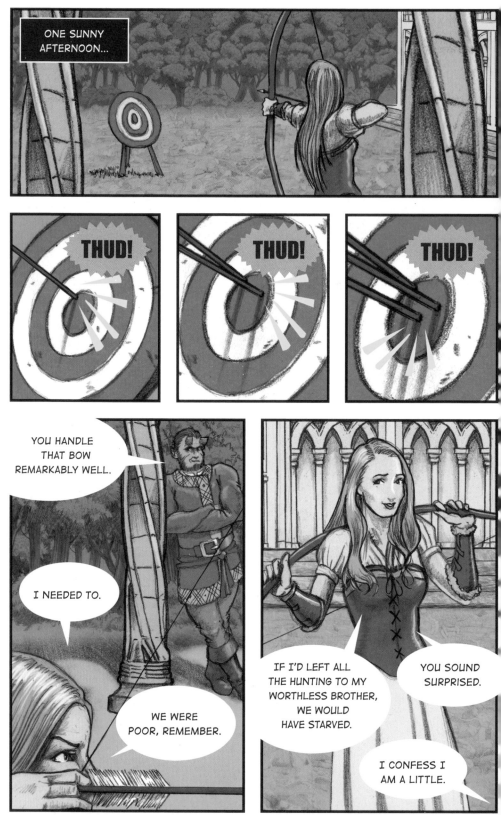

76

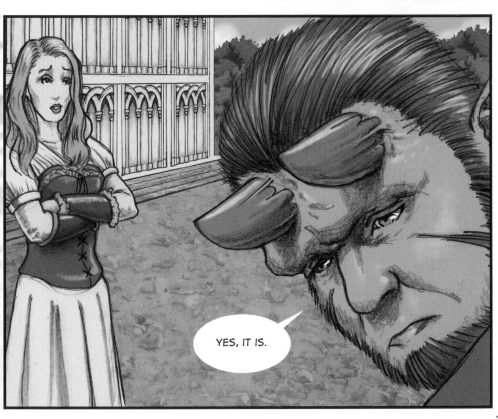

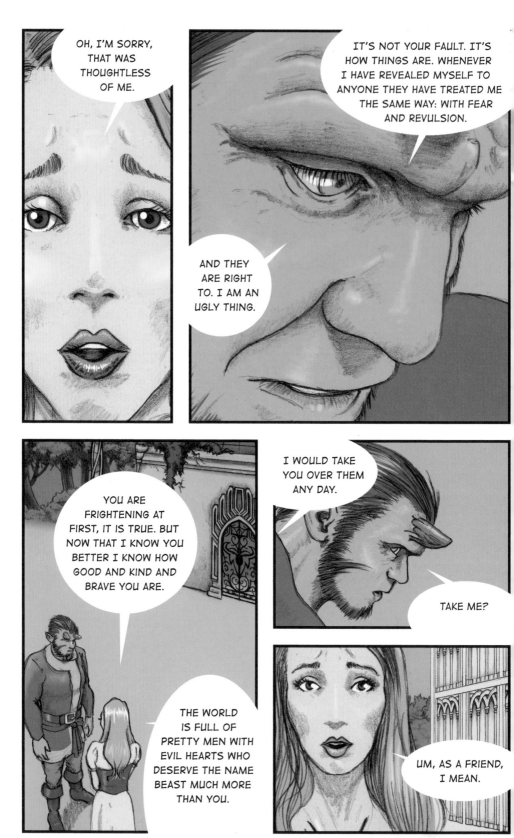

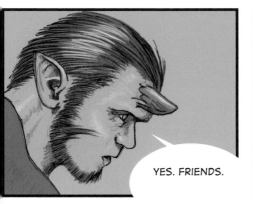

YES. FRIENDS.

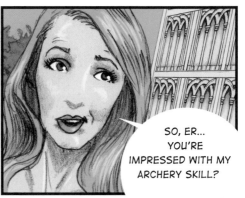

SO, ER... YOU'RE IMPRESSED WITH MY ARCHERY SKILL?

I AM. IT IS A UNIQUE GIFT FOR A MERCHANT'S DAUGHTER. EMBROIDERY WOULD BE MORE TRADITIONAL, I THINK.

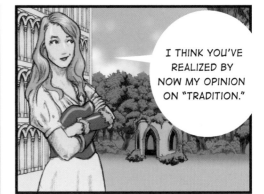

I THINK YOU'VE REALIZED BY NOW MY OPINION ON "TRADITION."

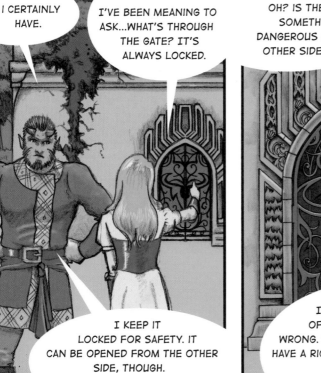

I CERTAINLY HAVE.

I'VE BEEN MEANING TO ASK...WHAT'S THROUGH THE GATE? IT'S ALWAYS LOCKED.

I KEEP IT LOCKED FOR SAFETY. IT CAN BE OPENED FROM THE OTHER SIDE, THOUGH.

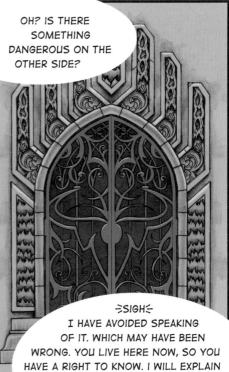

OH? IS THERE SOMETHING DANGEROUS ON THE OTHER SIDE?

≷SIGH≷
I HAVE AVOIDED SPEAKING OF IT. WHICH MAY HAVE BEEN WRONG. YOU LIVE HERE NOW, SO YOU HAVE A RIGHT TO KNOW. I WILL EXPLAIN OVER SUPPER.

THERE IS A TALE TOLD
AROUND THESE PARTS
ABOUT A GLORIOUS
CASTLE THAT SITS ON
ENCHANTED LAND.

A MAGICAL CASTLE THAT
HOLDS MANY ROOMS AND
TREASURES:
CHESTS OF GOLD THAT
NEVER EMPTY; TABLES
ALWAYS LADEN FOR A
BANQUET, NO MATTER
HOW MUCH IS EATEN;
INSTRUMENTS THAT PLAY
THEMSELVES; FIRES THAT
LIGHT THEMSELVES—
ANYTHING A PERSON
WISHES FOR, THE
CASTLE PROVIDES.

THIS CASTLE IS
SURROUNDED BY WOODS
AND IS NOT EASY TO FIND.
IT LIES VACANT, LURING
UNWARY TRAVELERS AND
VAGABONDS, READY TO
SERVE ANYONE WILLING
TO DECLARE IT AS
THEIR HOME.

BUT, AS IS ALWAYS THE
CASE, ALL THIS TREASURE
AND MAGIC COMES WITH A
HEAVY PRICE.

NOT FAR FROM THE
CASTLE IS A GATE...

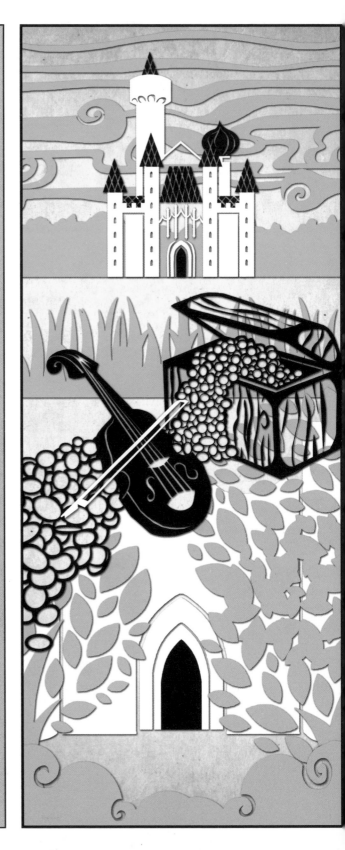

...BEYOND THE GATE LIES A WELL.
A DEEP WELL.
SO DEEP, IN FACT, THAT IT REACHES ALL THE WAY TO THE UNDERWORLD.
TO THE LAIR OF A DEMON.
A DEMON WHO, IT IS SAID, CANNOT BE HARMED BY MAN AND CANNOT BE KILLED BY ANY WEAPON OF MAN.

THIS DEMON CLAIMS OWNERSHIP OF THE BEAUTIFUL CASTLE AND THE LAND THAT SURROUNDS IT.
ONCE A YEAR HE MAKES THE JOURNEY FROM THE UNDERWORLD TO HIS PROPERTY, TO COLLECT HIS RENT FROM ANY UNSUSPECTING TENANTS WHO HAVE TAKEN UP RESIDENCE THERE.

IF YOU CAN BEAT THE DEMON IN A DUEL OF SINGLE COMBAT, YOU ARE FREE FROM PAYMENT.

IF YOU CANNOT (AND IT IS BELIEVED NO ONE HAS), HE TAKES YOUR SOUL.

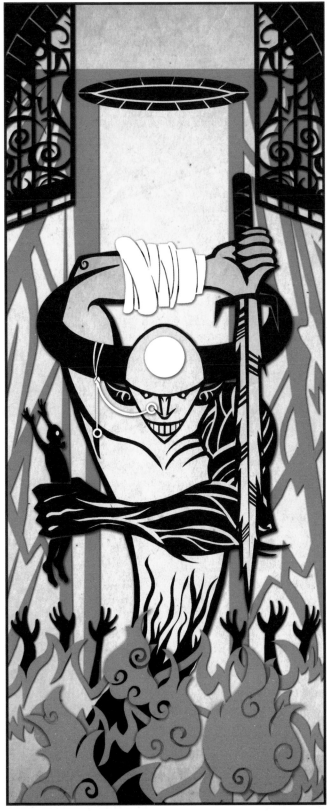

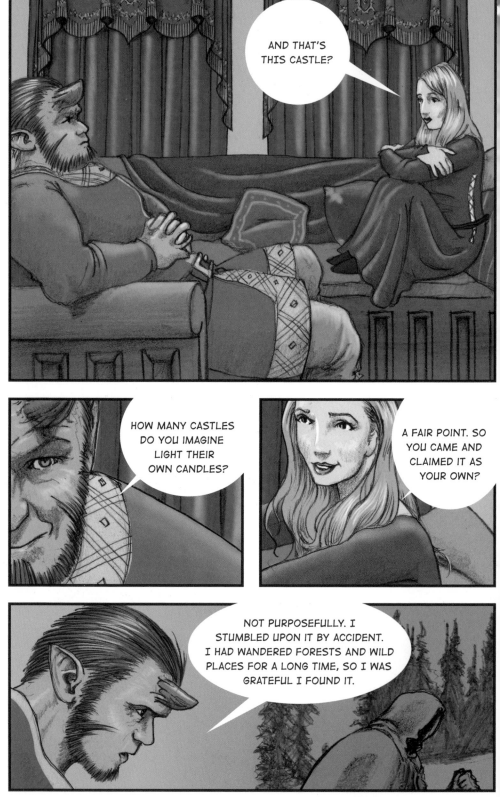

I HAD HEARD THE TALE, SO I SOON REALIZED WHERE I HAD COME. BUT I WASN'T SCARED. I COULD LIVE IN COMFORT, PURSUE MY INTERESTS, AND ABOVE ALL, AVOID MANKIND. IT IS PERFECT FOR ME, EVEN WITH THE HIGH TOLL.

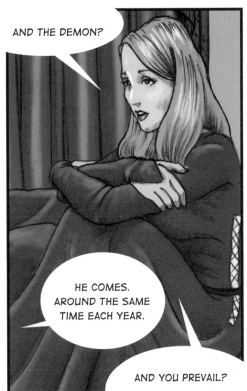

AND THE DEMON?

HE COMES. AROUND THE SAME TIME EACH YEAR.

AND YOU PREVAIL?

YES, HAVE NO FEAR ON THAT POINT. I WON'T SAY THE TASK IS EASY. INDEED IF I WERE A NORMAL MAN I COULDN'T HOPE TO TRIUMPH, BUT AS A LUMBERING BEAST I HAVE THE STRENGTH TO MATCH HIM.

I SUPPOSE THERE IS SOME IRONY IN THAT.

ONLY I CAN DEFEAT HIM, SO I STAY TO SAFEGUARD ANYONE WHO MAY FIND THEMSELVES HERE.

I WONDER IF HE EVEN REALIZES HOW ADMIRABLE THAT IS.

83

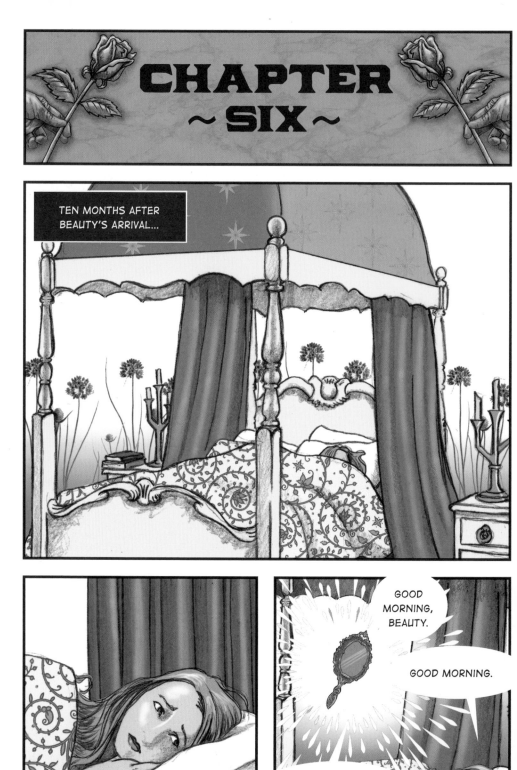

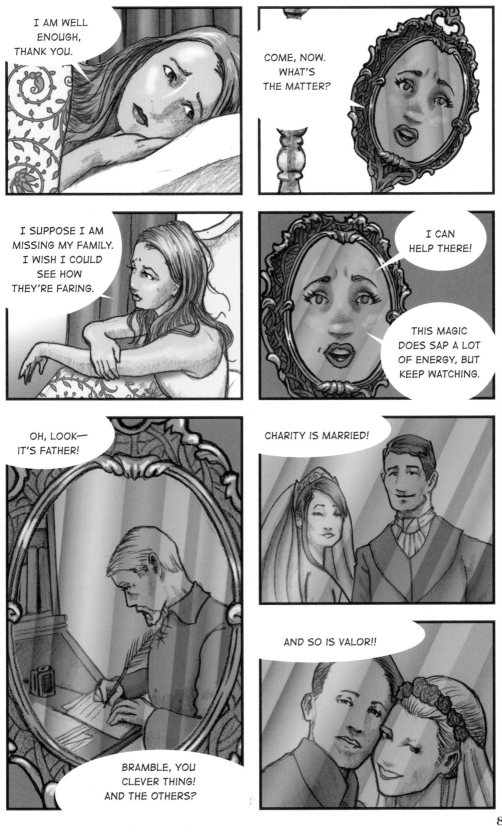

85

THANK YOU, BRAMBLE! THAT WAS WONDERFUL!

BOTH MARRIED! I SUPPOSE THANKS TO BEAST, THEY EACH HAD A LARGE ENOUGH FORTUNE TO ATTRACT A PARTNER. LUCKY FOR THEM.

LUCKY INDEED.

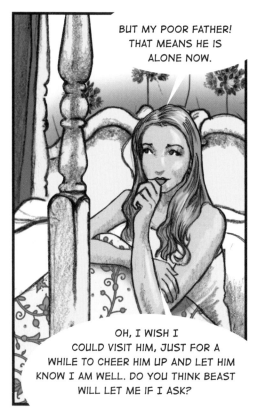

BUT MY POOR FATHER! THAT MEANS HE IS ALONE NOW.

OH, I WISH I COULD VISIT HIM, JUST FOR A WHILE TO CHEER HIM UP AND LET HIM KNOW I AM WELL. DO YOU THINK BEAST WILL LET ME IF I ASK?

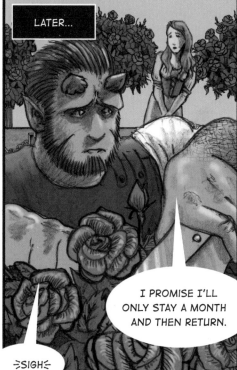

LATER...

I PROMISE I'LL ONLY STAY A MONTH AND THEN RETURN.

≷SIGH≷

86

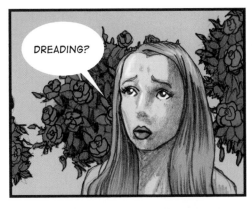

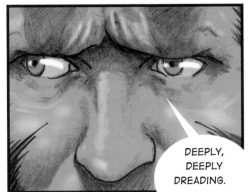

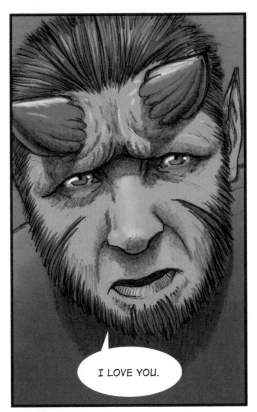

WE HAVE SPENT EVERY DAY TOGETHER FOR MONTHS, AND I HAVE NEVER BEEN HAPPIER IN MY LONG LIFE. SO THE THOUGHT OF A MONTH WITHOUT YOU NOW IS TERRIFYING TO ME.

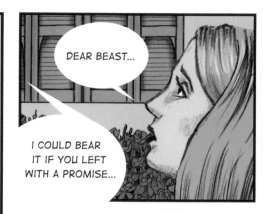

DEAR BEAST...

I COULD BEAR IT IF YOU LEFT WITH A PROMISE...

HAD I NEVER KNOWN YOUR COMPANY, IT WOULD BE EASIER. BUT I AM NOW A HOSTAGE TO MY FEELINGS.

TO ONE DAY BE MY WIFE.

OH, BEAST. THAT CANNOT BE. I DO CARE FOR YOU GREATLY. YOU ARE THE BEST MAN I HAVE EVER MET. BUT I DON'T THINK OF YOU IN THAT WAY, AND I CARE FOR YOU TOO MUCH TO PRETEND IT IS NOT SO.

YOU ARE MY DEAR FRIEND, MY DEAREST FRIEND, IN FACT. I WISH YOU COULD BE CONTENT WITH THAT.

I SHOULD BE GRATEFUL FOR YOUR FRIENDSHIP, I KNOW, BUT I AM A GREEDY, SELFISH BRUTE.

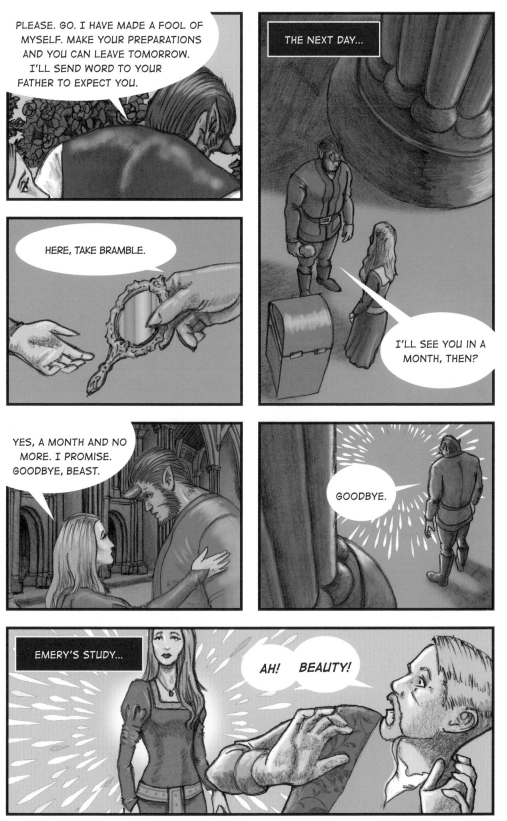

89

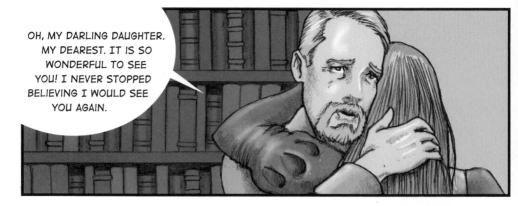

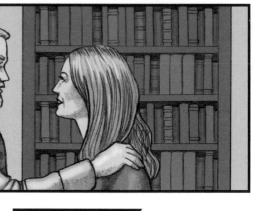

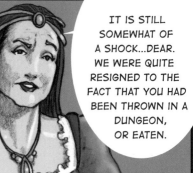

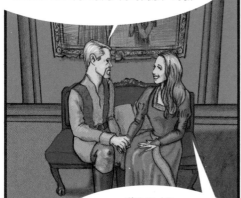

THANK YOU, BROTHER! WE WERE ALL AFRAID FOR NOTHING. BEAST IS NOT FRIGHTENING AT ALL. HE HAS BEEN THE MOST WONDERFUL, KIND, AND UNDERSTANDING FRIEND A PERSON COULD EVER HOPE FOR.

I CAN HONESTLY SAY I HAVE NEVER BEEN HAPPIER! WE SPEND OUR DAYS WALKING, EXPLORING THE CASTLE, OR MAKING USE OF THE VAST LIBRARY. OR JUST TALKING. IT IS ALMOST IDYLLIC.

BUT ENOUGH ABOUT ME! I WANT TO HEAR EVERYTHING. ARE YOU IN BUSINESS AGAIN, FATHER? WHAT ABOUT THE TWO OF YOU? MARRIED! HOW EXCITING! I HOPE I SHALL MEET YOUR SPOUSES SOON?

LATER...

I HAVE WORRIED ABOUT YOU EVERY DAY SINCE YOU LEFT. BUT I CAN SAY IT WAS THE ONLY TROUBLE I HAVE SUFFERED. WE ALL LIVE VERY COMFORTABLY, THANKS TO YOUR SACRIFICE.

ER, YES, WE WILL ARRANGE A DINNER SOON. IT WILL BE... MOST PLEASANT.

YOU CAN HARDLY CALL IT THAT, REALLY. BEAST WENT ABOUT IT IN A STRANGE WAY BUT IT IS LOVELY TO KNOW THAT, THANKS TO HIM, EVERYONE IS NOW CONTENT. IT MAKES ME VERY HAPPY.

TO BE HONEST, DEAREST, I DON'T THINK YOUR BROTHER AND SISTER WILL EVER BE CONTENT. THEY WILL ALWAYS BE UNGRATEFUL AND ILL-TEMPERED. THEY BOTH MARRIED WELL, BUT UNFORTUNATELY, MARRIED PEOPLE TOO SIMILAR TO THEMSELVES.

VALOR'S WIFE IS BEAUTIFUL, BUT AS CONCEITED AS HIM. WHEN SHE IS NOT STARING AT HER OWN REFLECTION, SHE IS OUT ENJOYING THE ATTENTION OF ADMIRERS.

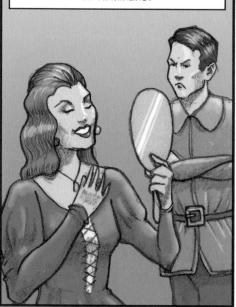

CHARITY MARRIED A HANDSOME MAN OF WIT. BUT HIS WIT IS AS CAUSTIC AS HERS, AND THEY ARGUE CONSTANTLY.

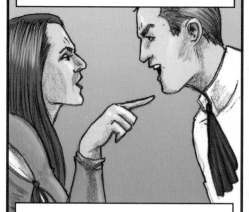

CONSEQUENTLY, YOUR BROTHER AND SISTER STILL SPEND MOST OF THEIR TIME TOGETHER AS THEY SEEM TO BE THE ONLY PEOPLE THEY CAN TOLERATE.

HEAVEN KNOWS WHAT THEY FIND TO TALK ABOUT...

AT CHARITY'S TWO WEEKS LATER...

DO YOU SEE HOW SMUG OUR SISTER IS NOW? I CAN'T STAND IT!

HA! YES INDEED.

YOU KNOW SHE LOOKS DOWN AT US NOW? SITTING THERE IN HER FINE GOWNS. SHE LOOKS RIDICULOUS! LIKE A GOAT IN A FROCK-COAT.

IT *IS* SICKENING. WHY DOES SHE DESERVE TO BE SO DAMN HAPPY? WHAT HAS *SHE* EVER DONE TO WARRANT SUCH GOOD FORTUNE WHEN WE ARE CONSTANTLY PUNISHED BY FATE? SHE GETS TO LIVE IN A FINE CASTLE WITH UNTOLD RICHES, WHILE WE LINGER IN THIS TEDIOUS TOWN WITH TEDIOUS PEOPLE.

IT MAKES ME SO ANGRY. THE INJUSTICE OF IT. THAT MONSTER WAS SUPPOSED TO FINISH HER OFF! WHAT GOOD IS A BEAST THAT DOESN'T KILL?

EXCUSE ME?

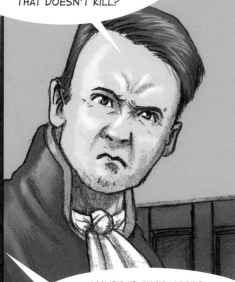

MAYBE IT JUST NEEDS MORE INCENTIVE.

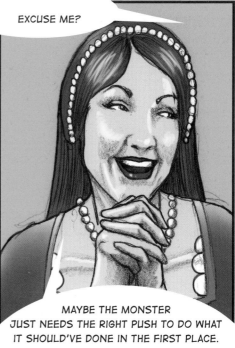

MAYBE THE MONSTER JUST NEEDS THE RIGHT PUSH TO DO WHAT IT SHOULD'VE DONE IN THE FIRST PLACE. I HAVE AN IDEA. ALL WE NEED ARE SOME ONIONS AND THE KEY TO PAPA'S IRON DOCUMENT BOX...

CHAPTER
~ SEVEN ~

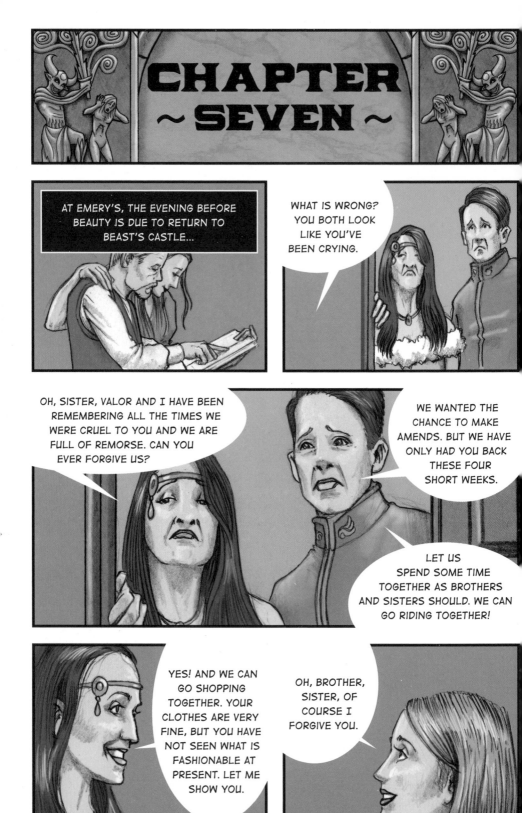

AT EMERY'S, THE EVENING BEFORE BEAUTY IS DUE TO RETURN TO BEAST'S CASTLE...

WHAT IS WRONG? YOU BOTH LOOK LIKE YOU'VE BEEN CRYING.

OH, SISTER, VALOR AND I HAVE BEEN REMEMBERING ALL THE TIMES WE WERE CRUEL TO YOU AND WE ARE FULL OF REMORSE. CAN YOU EVER FORGIVE US?

WE WANTED THE CHANCE TO MAKE AMENDS. BUT WE HAVE ONLY HAD YOU BACK THESE FOUR SHORT WEEKS.

LET US SPEND SOME TIME TOGETHER AS BROTHERS AND SISTERS SHOULD. WE CAN GO RIDING TOGETHER!

YES! AND WE CAN GO SHOPPING TOGETHER. YOUR CLOTHES ARE VERY FINE, BUT YOU HAVE NOT SEEN WHAT IS FASHIONABLE AT PRESENT. LET ME SHOW YOU.

OH, BROTHER, SISTER, OF COURSE I FORGIVE YOU.

ALL I HAVE EVER WANTED WAS FOR US TO GET ALONG LIKE OTHER FAMILIES. I WOULD LOVE TO SPEND SOME TIME TOGETHER, BUT I CANNOT.

I PROMISED BEAST MOST FAITHFULLY THAT I WOULD RETURN TOMORROW. I BELIEVE HE WOULD WORRY GREATLY IF I DID NOT RETURN.

SURELY A FEW MORE DAYS WILL NOT MATTER? HE MAY HARDLY NOTICE, WORKING AWAY AT HIS ROSES.

PLEASE, BEAUTY, I WOULD BE DISTRAUGHT IF YOU LEFT US NOW AND WE MISSED THIS CHANCE TO BOND. WHO KNOWS WHEN WE WILL SEE YOU AGAIN?

I...SUPPOSE A FEW MORE DAYS WON'T MAKE MUCH DIFFERENCE.

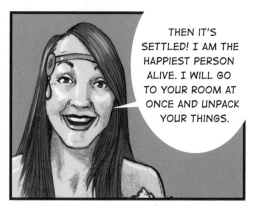

THEN IT'S SETTLED! I AM THE HAPPIEST PERSON ALIVE. I WILL GO TO YOUR ROOM AT ONCE AND UNPACK YOUR THINGS.

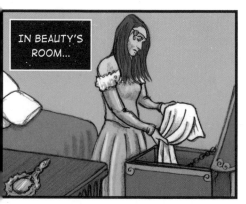

IN BEAUTY'S ROOM...

95

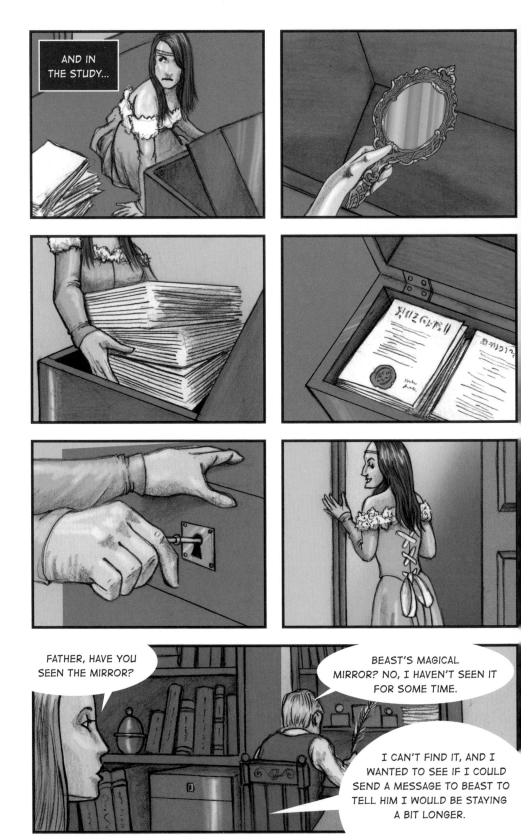

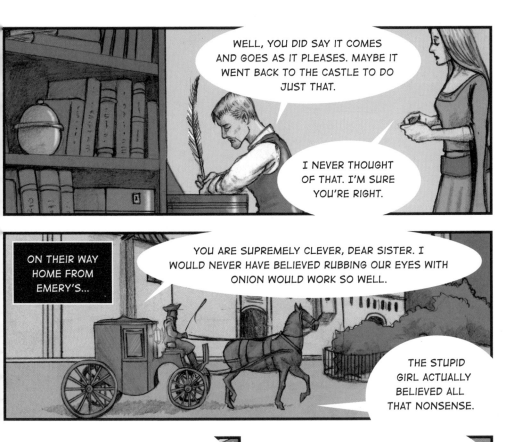

WELL, YOU DID SAY IT COMES AND GOES AS IT PLEASES. MAYBE IT WENT BACK TO THE CASTLE TO DO JUST THAT.

I NEVER THOUGHT OF THAT. I'M SURE YOU'RE RIGHT.

ON THEIR WAY HOME FROM EMERY'S...

YOU ARE SUPREMELY CLEVER, DEAR SISTER. I WOULD NEVER HAVE BELIEVED RUBBING OUR EYES WITH ONION WOULD WORK SO WELL.

THE STUPID GIRL ACTUALLY BELIEVED ALL THAT NONSENSE.

WELL, NOW WE MUST THINK UP REASONS TO KEEP HER HERE AS LONG AS POSSIBLE. THEN, WHEN SHE FINALLY RETURNS TO THE MONSTER, HE WILL BE SO ANGRY WITH HER, HE'LL TEAR HER APART.

I NEEDED A REASON TO ENTER HER ROOM! I GOT THAT MAGICAL MIRROR AND LOCKED IT IN PAPA'S IRON BOX.

THAT NONSENSE ABOUT YOU UNPACKING FOR HER WAS A BIT OVERDONE.

EVERYONE KNOWS IRON IS A WARD AGAINST MAGIC, SO THERE'LL BE NO POPPING BACK TO THE CASTLE FOR HER UNTIL WE SAY.

YOU ASTOUND ME, SISTER!

I AM RATHER MARVELOUS AREN'T I?

AND SO FOR ALMOST A MONTH, BEAUTY ENJOYS A WHIRLWIND OF PARTIES, RIDING TRIPS, SHOPPING EXPEDITIONS, AND EVERY OTHER DIVERSION HER SIBLINGS CAN DEVISE. ONLY ONE THING TROUBLES HER...

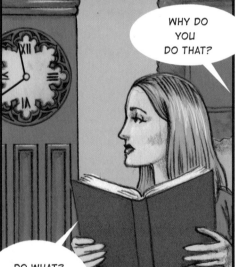

WHY DO YOU DO THAT?

DO WHAT?

EVERY DAY YOU START LOOKING AT THE CLOCK JUST BEFORE EIGHT O' CLOCK, LIKE YOU'RE EXPECTING SOMEONE TO ARRIVE.

DO I? I WASN'T AWARE OF IT. HABIT, I SUPPOSE.

HOW IS BEAST? WHY HAS HE NOT SENT BRAMBLE FOR ME?

HE PROBABLY WANTS TO LEAVE ME MORE TIME HERE, BLESS HIM, BUT I AM READY TO RETURN. I MISS HIS COMPANY.

MUCH MORE THAN I THOUGHT I WOULD.

DEAR BEAST, BE WELL.

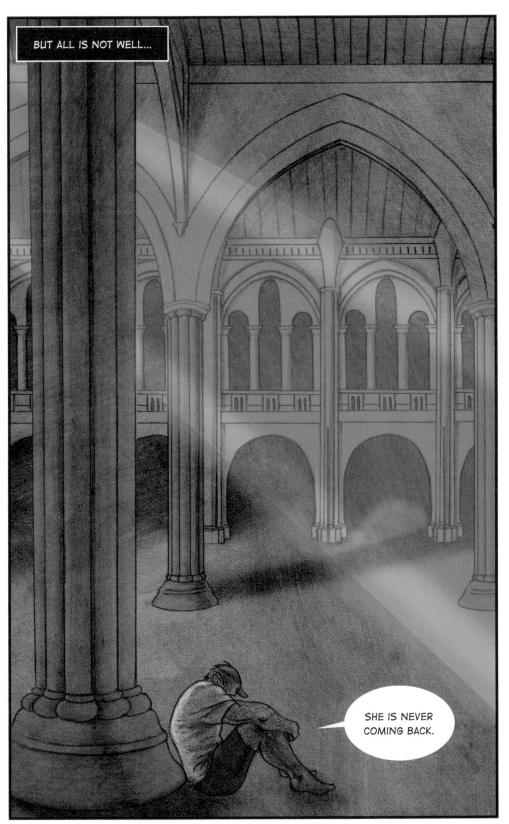

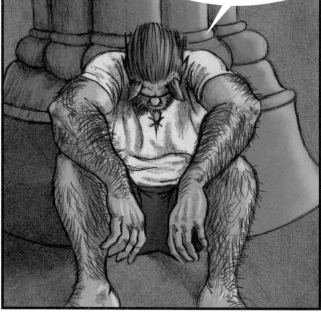

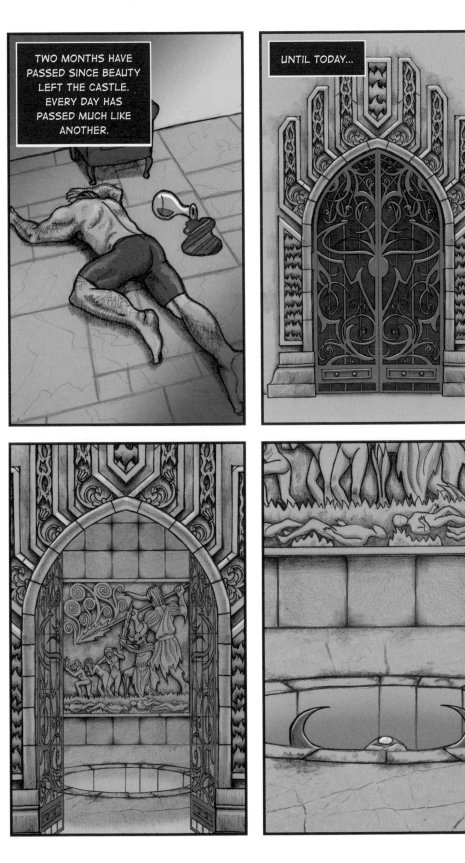

101

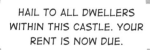

HAIL TO ALL DWELLERS
WITHIN THIS CASTLE. YOUR
RENT IS NOW DUE.

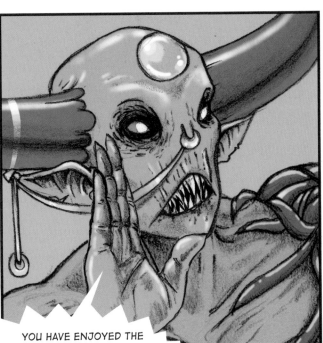

YOU HAVE ENJOYED THE PLEASURE OF LIVING IN THIS PLACE FOR ANOTHER YEAR, AND CALIBAN IS HERE FOR HIS PAYMENT.

≥SIGH≤

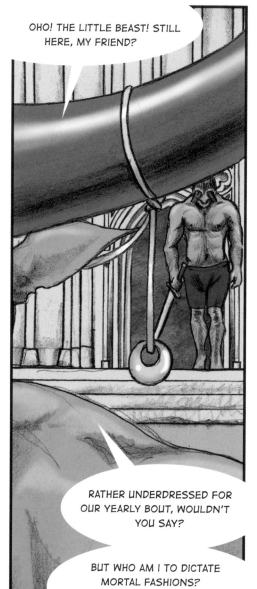

OHO! THE LITTLE BEAST! STILL HERE, MY FRIEND?

RATHER UNDERDRESSED FOR OUR YEARLY BOUT, WOULDN'T YOU SAY?

BUT WHO AM I TO DICTATE MORTAL FASHIONS?

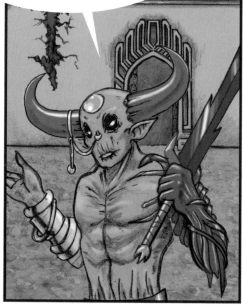

YOU'RE QUIETER THAN NORMAL. NO "PROTECTING THE INNOCENT" SPEECH THIS TIME? ARE YOU SO EAGER TO BEGIN OUR NEXT ROUND?

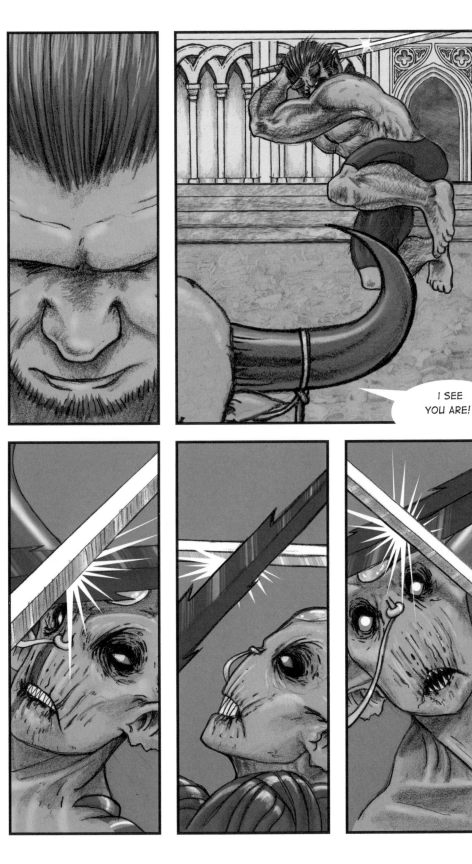

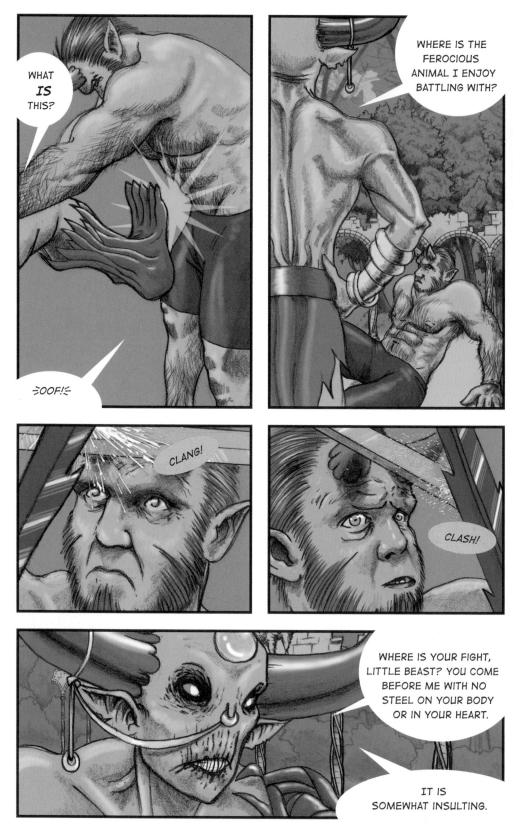

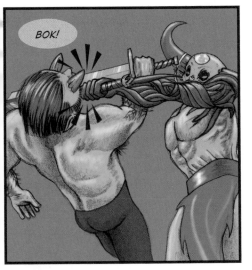

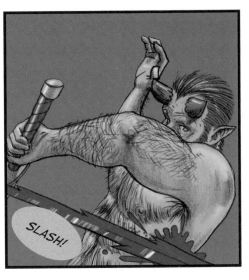

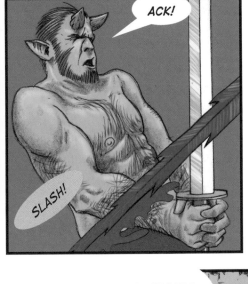

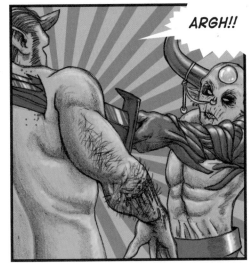

WHAT AN AGREEABLE DAY THIS HAS TURNED OUT TO BE! I HAD NO IDEA I WOULD BE COLLECTING YOUR LONG OVERDUE PAYMENT!

HOW MANY TIMES HAVE YOU BEATEN ME BACK TO THE WELL? MORE THAN I'D CARE TO ADMIT.

SO MANY THAT I WILL RELISH THIS DAY AND TAKE MY TIME WITH YOU.

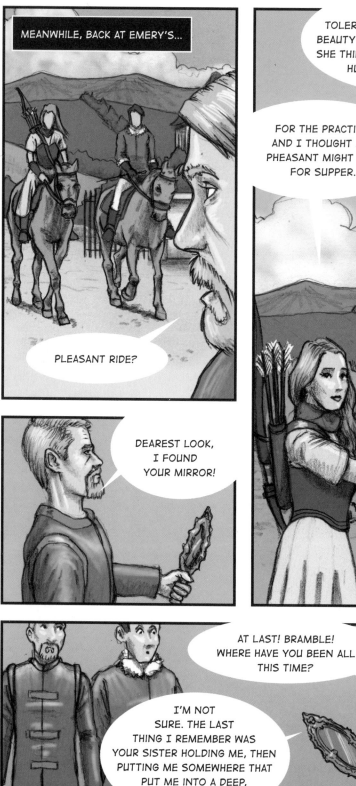

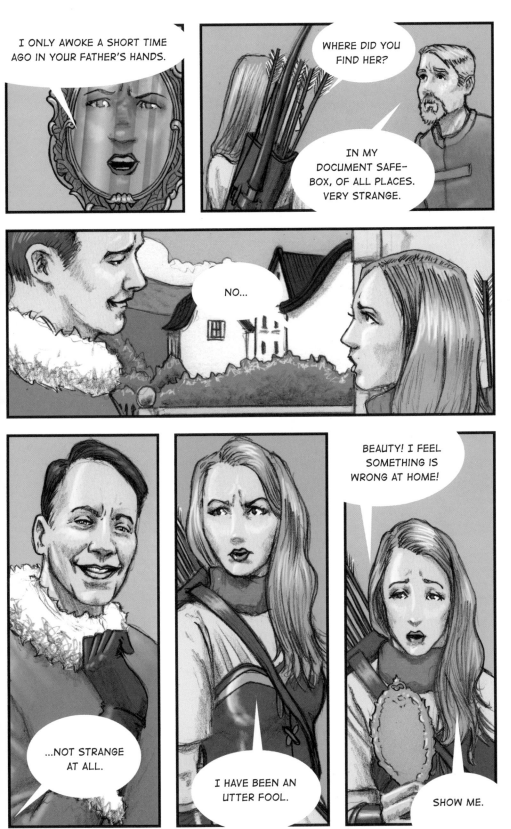

109

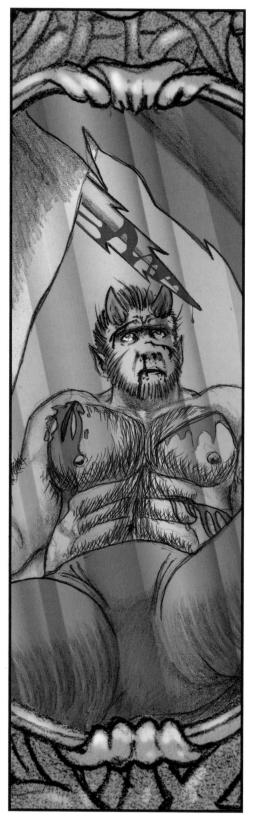

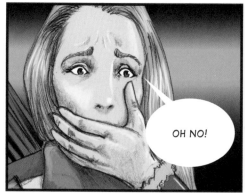

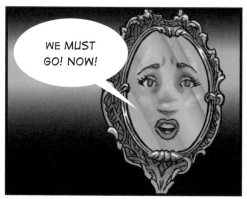

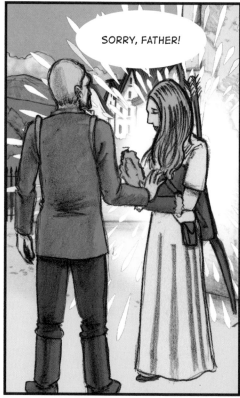

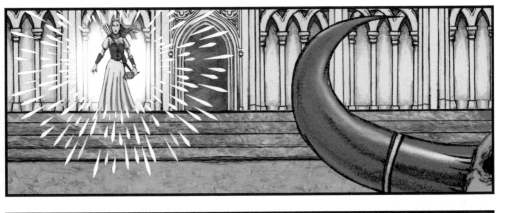

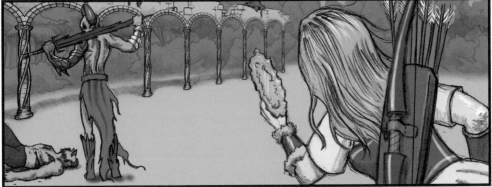

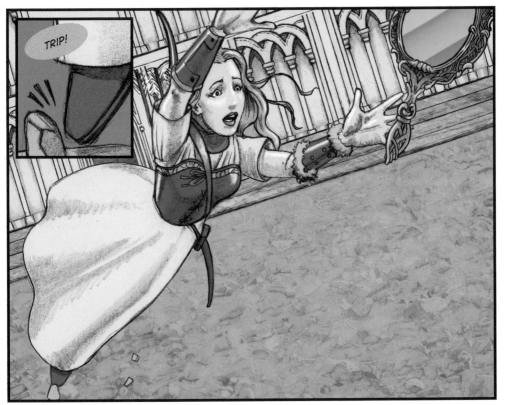

TRIP!

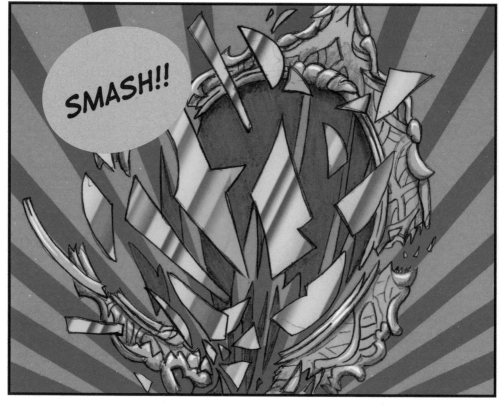

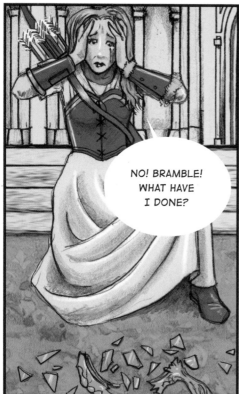

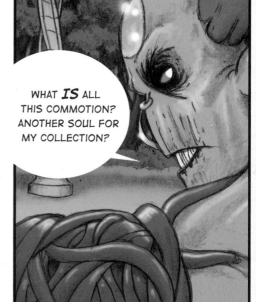

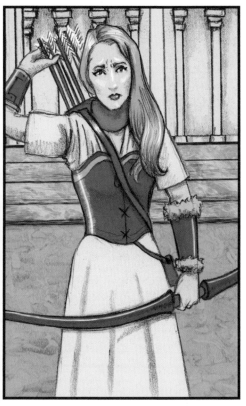

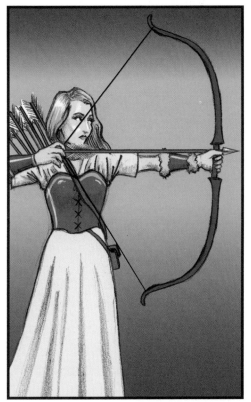

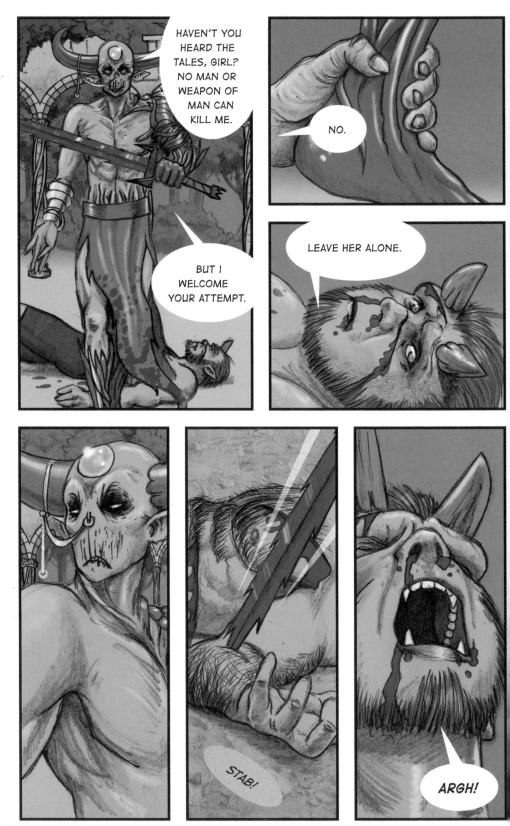

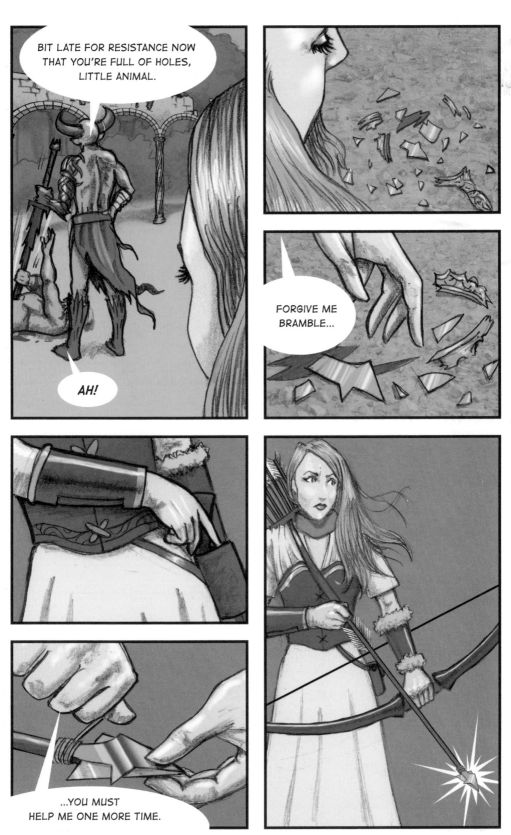

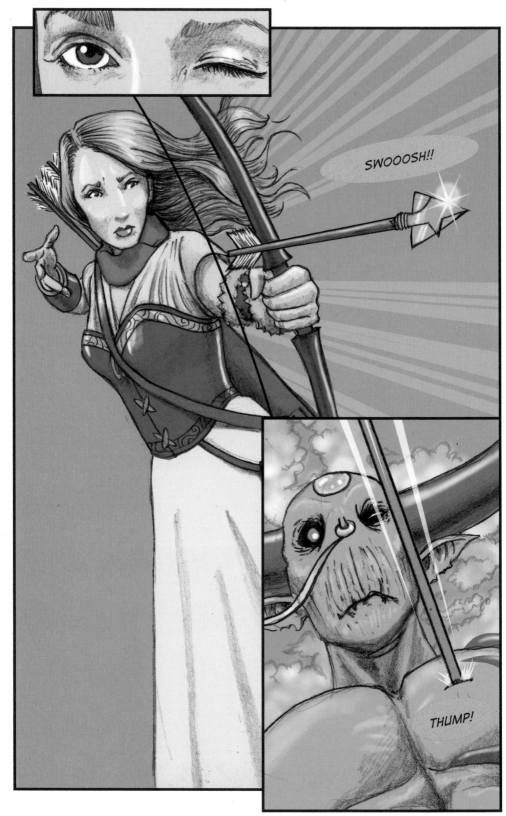

SWOOOSH!!

THUMP!

116

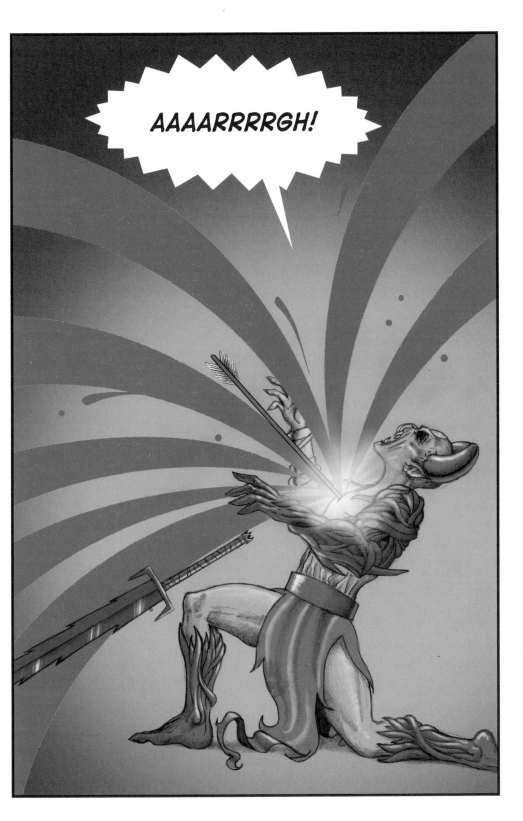

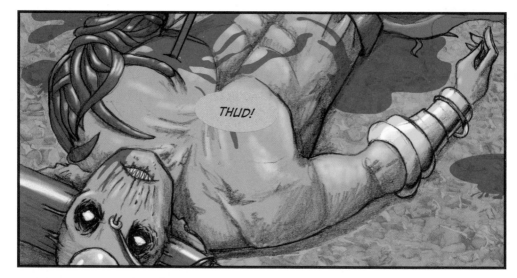

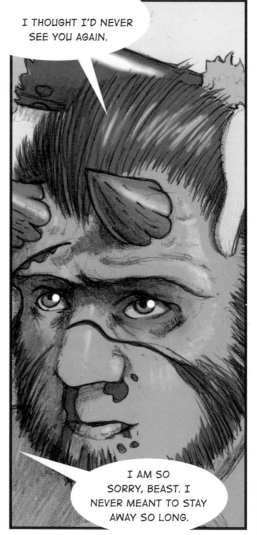

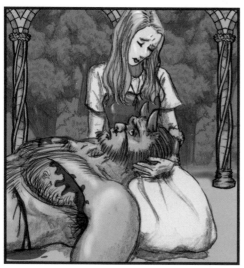

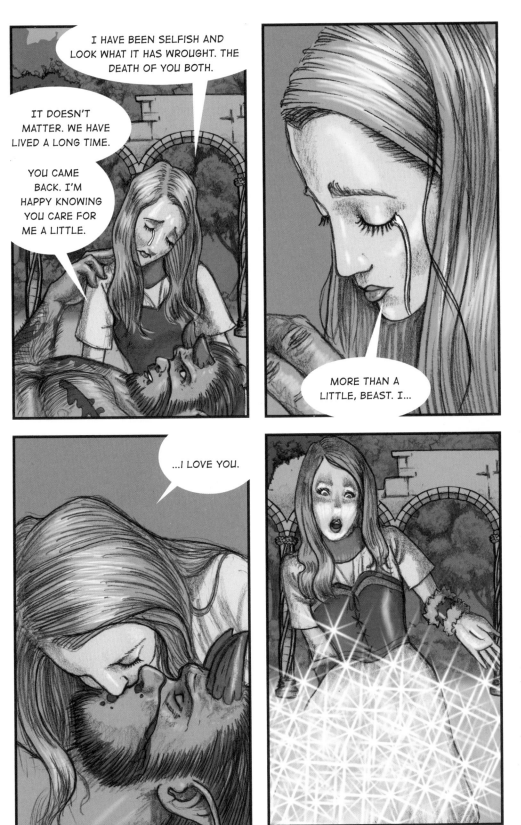

119

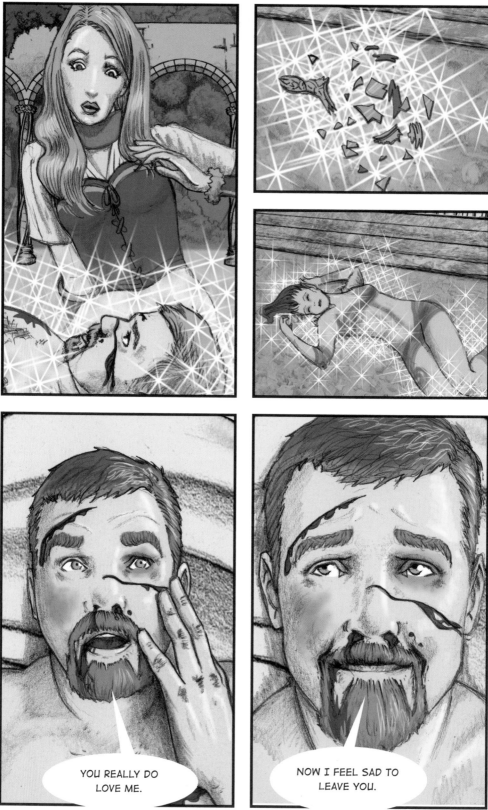

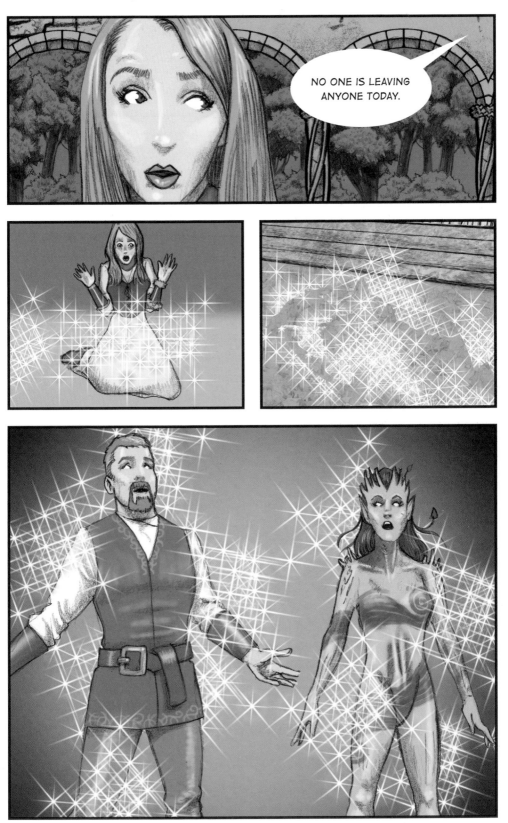

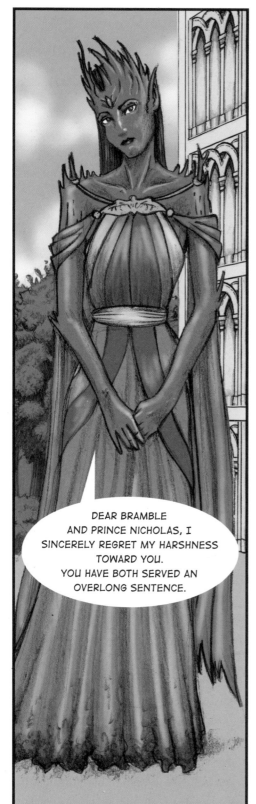

DEAR BRAMBLE AND PRINCE NICHOLAS, I SINCERELY REGRET MY HARSHNESS TOWARD YOU. YOU HAVE BOTH SERVED AN OVERLONG SENTENCE.

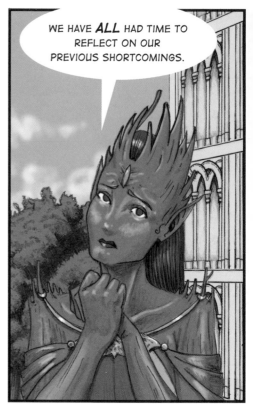

WE HAVE *ALL* HAD TIME TO REFLECT ON OUR PREVIOUS SHORTCOMINGS.

YOU BOTH DESERVE A CHANCE AT LIFE AS YOURSELVES.

AND PRINCE, YOU MAY RETURN TO YOUR OWN COUNTRY OR STAY HERE AT BEAUTY'S CASTLE. FOR IT IS HERS NOW BY RIGHT FOR DEFEATING ITS PREVIOUS OWNER.

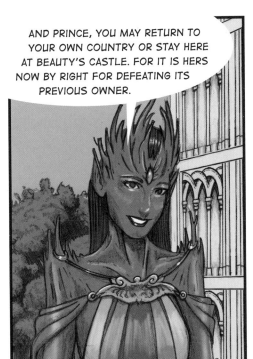

BRAMBLE, YOU MAY RETURN WITH ME TO THE KINGDOM OF FAERIE, IF YOU WISH. NOT AS A SERVANT BUT AS A LADY OF THE COURT.

HOW *DID* YOU MANAGE THAT? HE WAS INVULNERABLE!

AND IT WAS MEANT TO BE SINGLE COMBAT. IT'S JUST NOT THE DONE THING, YOU HELPING.

NOT THAT I'M COMPLAINING!

IF HE HADN'T BEEN SO BOASTFUL, I MIGHT NOT HAVE THOUGHT OF IT. HIS ARROGANCE KILLED HIM, THAT AND A WOMAN WITH A PIECE OF FAERIE MIRROR.

AND AS FOR "NOT THE DONE THING," YOU KNOW ME—I'M NOT ONE FOR TRADITION.

YOU ARE QUITE WONDERFUL, DO YOU KNOW THAT?

WELL, BRAMBLE, ARE YOU COMING BACK TO THE KINGDOM OF FAERIE?

THAT SOUNDS LIKE AN EXCELLENT IDEA! YOUR CASTLE'S NOT GOING ANYWHERE, BEAUTY. WE CAN ALWAYS RETURN. WE COULD FILL A BAG WITH GOLD AND JUST HEAD OUT.

NO OFFENSE, YOUR HIGHNESS, BUT I'M NOT READY TO TRADE ONE STUFFY CASTLE FOR ANOTHER. I FINALLY HAVE THE CHANCE TO SPREAD MY WINGS FOR A BIT. I'M GOING TRAVELING!

ONLY IF YOU'D LIKE TO, OF COURSE.

IT IS AN EXCELLENT IDEA. BUT WHY DON'T WE SHARE A LAST MEAL HERE TONIGHT AND START OUR JOURNEY TOMORROW?

WHY DON'T WE GO BY WAY OF OAKBRIDGE? YOU COULD VISIT YOUR FATHER AND I COULD TURN THOSE FOUL SIBLINGS OF YOURS INTO STATUES OR SOMETHING...IT WOULD BE MY PLEASURE!

I'M TOO HAPPY TO THINK OF PUNISHING ANYONE. ISN'T IT PUNISHMENT ENOUGH JUST BEING THEMSELVES?

CAN YOU IMAGINE? THEY WOULD BE THE MOST SOUR-LOOKING STATUES ANYONE HAD EVER SEEN!

125

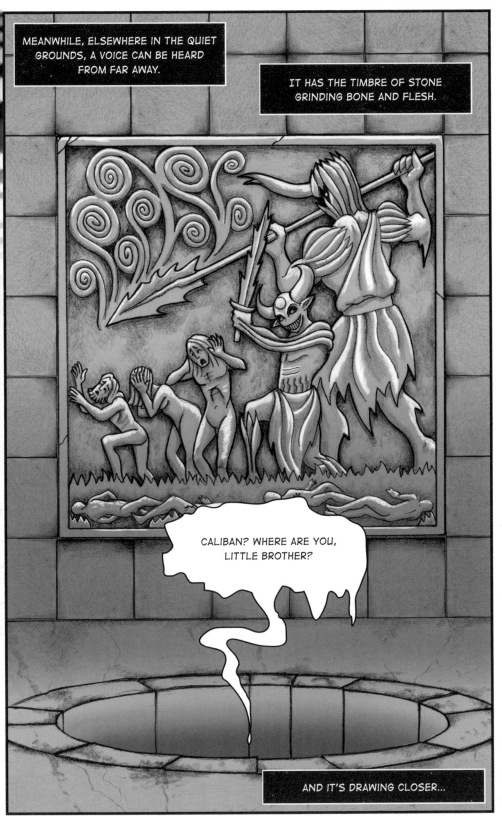

ACKNOWLEDGMENTS

A huge thank you to my models: Nick Jackson, Charlotte Nichols, Andrew Casey, Laura Thomas, Natalie Bowling and Sebastian Cheswright Cater.

Thanks to Lucy and James at Quid.

Much love and gratitude as ever to Paul Mayor, Ma, Cos and Ruth for their continued love and support. Big hugs to the rest of my family.

Thanks and big love to everyone else that puts up with me, especially: Andrew Casey, Richard Recardo, Nick Jackson, Stephen Pearce, Sebastian Cheswright-Cater, Rebecca Hull, Maxine Doyle, Ben Vincent, Keith Davie, Laura Thomas, Jon King, Alex and Steph, Kevin and Francie, Han and Karolien, Simon Hayward, Bill and Vicky, Paul Ryan, Jo Lloyd, Jon Byrne, Adam and Mari, the Bad Apples, the Reckless Records crew and all the gang from Brighton.